John Currin

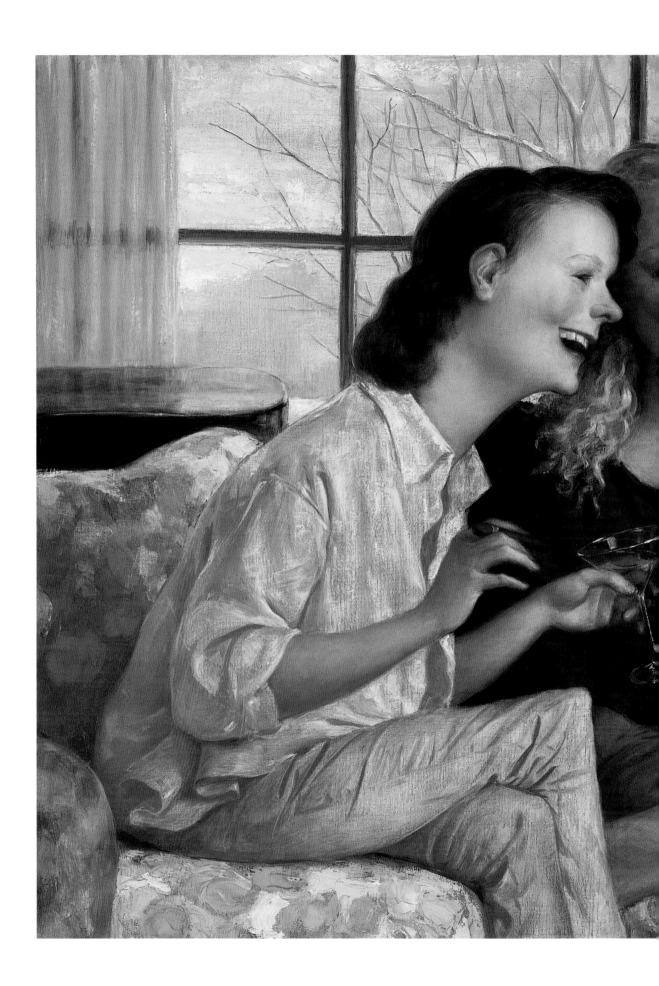

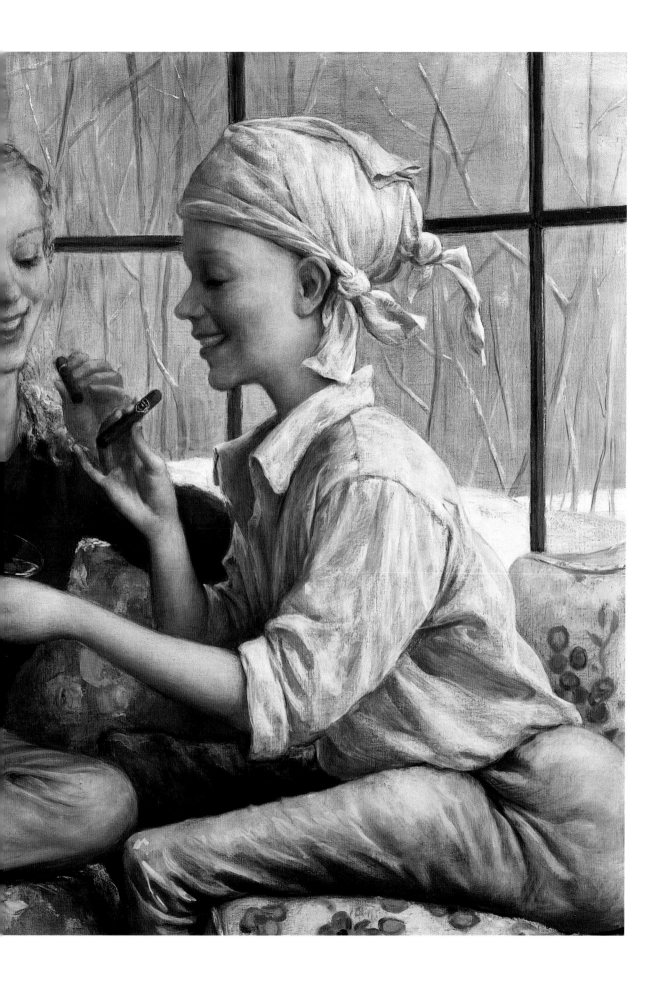

Exhibition curators
Staci Boris
Rochelle Steiner

Essays
Robert Rosenblum
Staci Boris

Interview
Rochelle Steiner

John

Currin

**Museum of
Contemporary
Art, Chicago**

**Serpentine
Gallery, London**

in association with

**Harry N.
Abrams, Inc.,
Publishers**

This catalogue was published in conjunction
with the exhibition *John Currin*, which was co-organized
by the Museum of Contemporary Art, Chicago,
and the Serpentine Gallery, London.

The exhibition was presented at

Museum of Contemporary Art, Chicago
May 3 – August 24, 2003

Serpentine Gallery, London
September 9 – November 2, 2003

Whitney Museum of American Art, New York
November 20, 2003 – February 22, 2004

Support for this exhibition has been provided by

Donna and Howard Stone

**Edwin C. Cohen and
The Blessing Way Foundation**

Andrea and James Gordon

David Teiger

Additional support has been provided by

Richard A. Lenon

The Museum of Contemporary Art, Chicago (MCA)
is a nonprofit, tax-exempt organization.
The MCA's exhibitions, programming, and
operations are member supported
and privately funded through contributions
from individuals, corporations, and foundations.
Additional support is provided through
the Illinois Arts Council, a state agency.
Air transportation services are provided by
American Airlines, the official airline
of the Museum of Contemporary Art.

The Serpentine Gallery is an educational charity,
which receives one third of its annual funding
from the government through London Arts,
and Westminster City Council.
The remaining two thirds of the Serpentine Gallery's
income is raised through corporate sponsorship,
as well as the support of individuals
and charitable organisations.

© 2003 by the Museum of Contemporary Art, Chicago,
and the Serpentine Gallery, London

 Serpentine Gallery

Published in 2003 by the Museum of Contemporary Art,
Chicago, and Serpentine Gallery, London, in association with
Harry N. Abrams, Incorporated, New York

ISBN 0–8109–91888

Library of Congress Catalog Number: 2003102103

Produced by the Publications Department
of the Museum of Contemporary Art, Chicago,
Hal Kugeler, Director; Kari Dahlgren, Associate Director.

Edited by Kari Dahlgren

Designed by Hal Kugeler

For Harry N. Abrams, Inc.
Deborah Aaronson, Editor

Color separations by
Professional Graphics, Rockford, Illinois
Printed in Belgium by Snoeck-Ducaju & Zoon

Typeset in Gill Sans

10 9 8 7 6 5 4 3 2 1

Harry N. Abrams, Inc.
100 Fifth Avenue
New York, N.Y. 10011
www.abramsbooks.com

Abrams is a subsidiary of

Full captions for works by John Currin are on pages 115 – 17
and photography credits are on page 124.

COVER *The Pink Tree* (detail), 1999

FRONTISPIECE *Stamford After-Brunch*, 2000

Contents

Foreword

In the last decade John Currin has been celebrated as one of the most important and provocative artists of his generation. Among the few contemporary painters who have focused exclusively on the figure, Currin creates images of women — and to a lesser extent men and couples — that are as beautiful as they are unsettling. His nudes, genre scenes, and portraits have been characterized in this book by the art historian Robert Rosenblum as "American grotesque." Currin's paintings refer to such disparate sources as Italian and Northern Renaissance masters, the idyllic settings of Rococo artists such as Boucher and Fragonard, and Courbet's groundbreaking paintings, as well as popular illustrations from the early twentieth century and imagery from contemporary advertisements and fashion magazines.

Although Currin has received much critical acclaim, this survey marks his first solo exhibition in a museum in the United States and his first in a public gallery in the United Kingdom since 1995. Featuring a broad range of paintings from the past decade, the selection traces Currin's development from his single figures of the early nineties to his idealized nudes inspired by old-master paintings to his recent social scenarios.

This exhibition, the second collaboration between the Museum of Contemporary Art, Chicago, and the Serpentine Gallery, London, follows the successful collaboration for the exhibition *Mariko Mori* in 1998, and we are delighted to have the opportunity to work together again. The exhibition was co-curated by Staci Boris, Associate Curator at the MCA, and Rochelle Steiner, Chief Curator at the Serpentine, who have enjoyed a fruitful exchange.

This fine volume, published in association with Harry N. Abrams, Inc., Publishers, New York, is the first monograph on Currin's work. We would especially like to thank Robert Rosenblum for his outstanding essay. Staci Boris's thoughtful text and Rochelle Steiner's interview with the artist also represent considerable additions to the body of scholarship on the artist.

We are particularly grateful to the museums and individuals who have so generously and enthusiastically supported the exhibition by lending works from their public and private collections. This exhibition would not have been possible without their invaluable support and willingness to share their paintings with the public in the U.S. and the U.K. Our thanks also go to Maxwell L. Anderson, Alice Pratt Brown Director of the Whitney Museum of American Art, for his commitment to bringing the exhibition to New York.

We are especially indebted to MCA Trustee Donna Stone and her husband Howard, along with Edwin C. Cohen and The Blessing Way Foundation, who came forward at a very early stage to support this collaboration, and to MCA and Whitney Trustee James Gordon and his wife Andrea. Their generosity has proven crucial to the realization of the project and we are grateful to them for their commitment. We would also like to express our appreciation to David Teiger, who generously supported the publication of this catalogue, and to Dick Lenon for his enthusiastic commitment.

We are privileged that John Currin accepted the invitation to present his work at our institutions and are particularly indebted to him for the passion he has brought to all aspects of this project.

Robert Fitzpatrick
Pritzker Director, MCA

Julia Peyton-Jones
Director, Serpentine Gallery

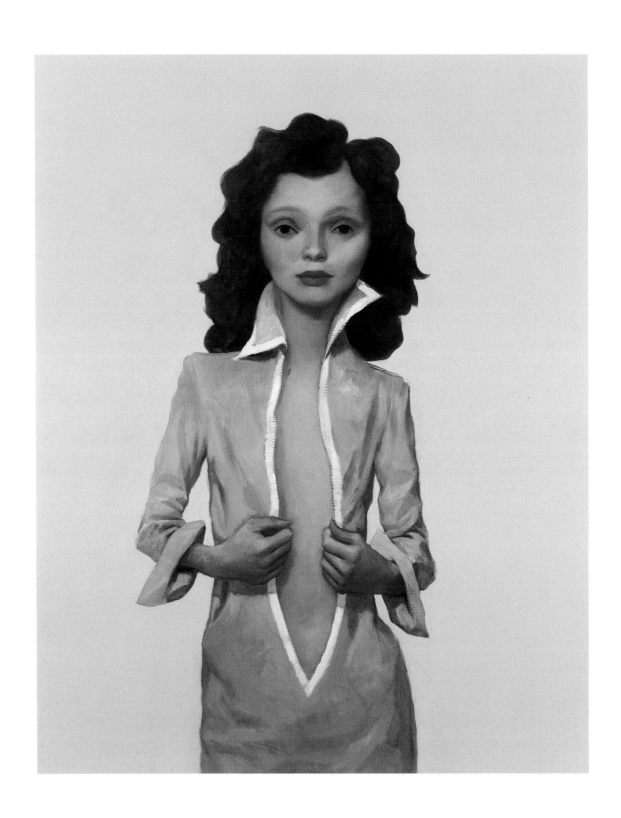

Ann-Charlotte, 1996

John Currin and the American Grotesque

Robert Rosenblum

For those fascinated by chronology, it's a happy coincidence that John Currin was born in 1962. In that year, Roy Lichtenstein had his first one-man show at the Leo Castelli Gallery and, to the horror of all sensitive, art-loving people, set forth a new vision of what might be called "the American grotesque." He found his sources in the oceans of unlooked-at visual trash that hurt the eyes of refined spectators, and disclosed, among other shocks in our image world, how strange, to the point of being hideous, the American ideal of female beauty could be. Culled from low-budget ads and comic strips, these ripe young girls, when enlarged and presented as oil paintings for close-up scrutiny, turned out to be monsters, belying their original purpose of seducing the vast unwashed American public into spending money on holiday resorts, soap operas, and kitchen appliances. The faces of this artificial race were discovered to have a paralyzed, masklike perfection (see p. 12); the limbs and torsos of their warped, steam-rolled bodies were entirely depleted of bone, joint, and muscle, so that their fluid contours could expand and contract at the artist's will. But of course the shock eventually wore off, and now these paintings look not like their commercial sources but like vintage, museum-worthy Lichtensteins, as much his private fantasy of the female body as were the nudes of Boucher or Canova, Ingres or Renoir. And on a less exalted, American wavelength, moving closer in time to Currin's grassroots heritage, one might mention the pinups of George Petty and his successor Alberto Vargas,

whose silk-smooth, pneumatic fantasies of rounded and elongated female flesh established their own new race of sex goddesses. From the 1930s through the 1960s, these shared erotic dreams kept arousing heterosexual subscribers to *Esquire* and *Playboy* and surely helped to inspire the pinup nudes that, in the early 1960s, also became the satirical focus of many works by Lichtenstein's pop contemporaries Tom Wesselmann and Mel Ramos. Today, of course, these mid-century objects of desire seem as remotely artificial and unsexy as Japanese erotica, having long ago become nostalgic documents of another era far less likely to prompt contemporary lust than to provide a field day for students of gender roles in American culture.

All of this may offer some preparation for looking at Currin's ever-expanding population of American humanoids, a completely original update of works by 1960s pioneers who were excited by the aesthetic potential lurking in the eeriness of contemporary America. One might begin, as Currin did, with the commonplace of portrait photographs, like those preserved in the high-school yearbooks we remember from our ever more distant youths. From 1989 on, this egalitarian format haunted him; and with a bias as predictable as Renoir's, he focused exclusively on the girls in the class (see pp. 25–27). Whether black or white, anonymous or named, these graduates set up a weird disparity between the belt-line formula — a frontal bust-length portrait silhouetted against a totally plain ground — and the quirkiness of individual mutations within this gallery of teenagers trying to look both proper and sexy,

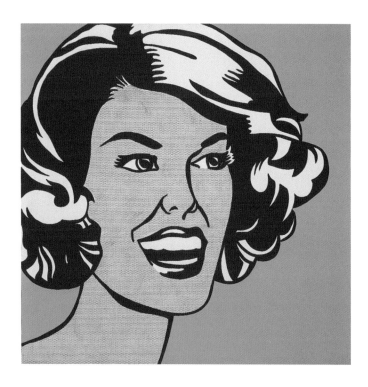

Roy Lichtenstein
(American, 1923–1997)
Head — Red and Yellow, 1962
Oil on canvas
48 x 48 in. (121.9 x 121.9 cm)
Collection of Albright-Knox
Art Gallery, Buffalo, N.Y., gift
of Seymour H. Knox, Jr., 1962
© Estate of Roy Lichtenstein

mixing angel hair and plucked eyebrows. The revival of a traditional hyperrealist style that fuses the old masters with hack commercial portraitists also adds macabre undercurrents, as if these mindless platitudes from every graduating class had been embalmed forever as motionless icons whom we can stare at as curious artifacts but who cannot return our gaze, not being quite human or alive. Moreover, their deadpan photographic likenesses begin to stir in strange ways, as we become slowly aware that their frozen demeanor conceals unexpected distortions of mind and body — an uncannily vacant or mock-serious expression that peers through the pastel, greeting-card colors; a curious irregularity of scale, with figures too large, too small, or too awkwardly placed within their empty spaces; or, perhaps most discomfiting, subliminal anatomical oddities that may turn up anywhere, whether in the shifting proportions between heads and bodies or the unexpected widening or narrowing of shoulders and

breasts. A new race is being born before our eyes, one that can embrace both the infinite variety and the sameness of American teenagers, as well as, on a rare occasion, even such a celebrity as the South African novelist and Nobel Prize–winner Nadine Gordimer (p. 35), now with the outsized head of an intellectual, as in a David Levine portrait caricature for the *New York Review of Books.* But even this world-famous writer, when reflected in Currin's distorting mirror, looks as though she might have been excerpted from the high-school yearbook's section of faculty photos, much as his equally exceptional double portrait of John F. Kennedy (1996), holding hands with his alter ego in drag, might also look like a giddy moment from the school principal's office party.

Less famous and usually anonymous adult women quickly became part of this growing portrait gallery, which often reflects, like antiquated etiquette books, those body types and social postures deemed fashionable for our time. The hand-on-hip pose comes in many variations, from the would-be intensity of a Shakespearean actress (1991, p. 28) to the caricatural extremes of the American ideal of unnaturally slender bodies, as in *Skinny Woman* (1992, p. 34) or the grotesquely aging *Ms. Omni* (1993, p. 36), half-skeleton, half-waxworks, paralyzed forever in her Gothic stance of arms fashionably akimbo and, as Roberta Smith put it, "as ready as she'll ever be for her close-up."[1] As with the teenage portraits, the placement of these middle-aged socialites against a plain background is usually awry (off-center, too high, too low), adding new dimensions to the disparity between their efforts at stylish grace and the actual facts of flesh and clothing, a contrast that can recall the way Goya subtly undermined so many of his fashionable sitters.[2] Moreover, these contemporary witches radiate an uncomfortable aura of stopped time, even of death, an effect far more overt in the 1993 sequence of variations on the theme of a girl lying in bed (pp. 39 and 41). Her head lies totally still on a white pillow, her body is covered with a white sheet up to her neck, and her pale face is discreetly

enhanced with makeup. Is she napping, is she ill or, closer to the bone, does she offer a gloss on the cosmetic skills of the modern American mortician?

This uncanny slipping from life to death, from the natural to the synthetic, from ordinary people to new kinds of body snatchers was, in fact, a growing phenomenon in late twentieth-century art. In 1992–93, this new world of virtual humans was iso-lated and christened by Jeffrey Deitch in an exhibition titled *Post Human.*[3] Considering first the proliferating onslaught of ways in which contemporary humans can transform themselves or enjoy surrogate experiences (a range that would include nose jobs, face lifts, breast implants, computer alteration, electronic communication, video games, and virtual sex), he then presented a large number of artists who mirrored our ever stranger versions of virtual reality — among others, Matthew Barney, Charles Ray, Robert Gober, Paul McCarthy, Cindy Sherman, and Jeff Koons. Currin was too new on the scene to have been included. (After his 1989 debut at White Columns, his first newsworthy show was not until March–April 1992 at the Andrea Rosen Gallery.) But now, with hindsight, we know how well he would have fit into this group, a young Frankenstein who made his monsters not only from the old masters but from the humanoid fantasies of contemporary America.

In inventing these creatures, sex, for Currin, soon became the driving engine. Even Bea Arthur, star of *Golden Girls,* the TV series about aging singles who still want be sexy and meet Mr. Right, gets stripped in a flabbergasting "portrait" of 1991 (p. 29) in which Ms. Arthur appears to be posing as a demure senior citizen who by some bizarre accident is stark naked, her slightly sagging breasts fully exposed. Or conversely, in *Big Lady* of 1993 (p. 37), a dour, white-haired suburban matron wears a neck-high woolen sweater that amplifies rather than conceals her gargantuan chest. Pinup fantasies lurk strangely in these images of what appear to be very real people undressed in the artist's imagination. In

fact, several paintings of 1994 are direct spoofs of conventional pinup anatomies, an update of the aging Picabia's delight in transforming French girlie magazines of the 1940s into oil on canvas (see p.14). But Currin's predictably blonde nudes display their assets in uncomfortably cramped postures and spaces that transform the erotic abandon of, say, Goya's *Naked Maja* into unexpectedly stressful situations of mind and body. Above all, it is breasts that

Charles Ray
(American, b. 1953)
Fall '91, 1992
Mixed media
96 x 26 x 36 in.
(243.8 x 66 x 91.4 cm)
Courtesy of Regen
Projects, Los Angeles

fascinate Currin, as indeed they had fascinated all of moviegoing America in the mid-century, the heyday of Jane Russell (who measured in at 38 inches) and, a bit later, Jayne Mansfield (who measured in at 41 inches), not to mention Diana Dors, the British contribution to this busty sorority. On this wave-length, Currin himself claimed, in a recent interview,[4] that he was not only a collector of 1960s girly photos from such magazines as *Modern Man,* but was also a big fan of Frank Frazetta's comics, particularly *Conan the Barbarian,* with its big-breasted superwomen. And it might be mentioned that these traditions are still alive and well in contemporary America, witness

the ever-expanding restaurant chain Hooters (founded in Texas in 1983) or the monthly anthology of mega-breasts offered by *Juggs* magazine, which, in fact, singled Currin out for "paying attention to the worthy theme of big tits."[5]

Currin drives this obsession to unnerving extremes, so that even breast-feeding, as in *The Nursery* (1994), makes one wallow and squirm in its unsavory fusion of an oversized-bosomed pinup girl and the presumably sexless pleasures of maternity. Elsewhere, such a disquieting marriage of bombshell breasts with ideal motherhood is, if possible, pushed even further. In *The Invalids* (1997, p. 50), a Jayne Mansfield understudy plays the soap-operatic role of a mother who, in the most awkwardly angular linking of arms, exchanges a comforting embrace with her blonde, handicapped daughter, a junior pinup tragically confined to a wheelchair. When freed from domestic obligations, these ballooning Venuses can concentrate on their body's most important attribute. In provocative pairings that conjure up overtures to lesbian pornography, they competitively admire each other's breasts and, with tape measures and bras in hand, go about the feminine business of finding the proper underclothing to cantilever their freakish assets (see pp. 66–67). And at times, they invade Currin's earlier rural idyls of languishing blonde country girls bathed in the kitsch sunlight of picture-postcard hills and valleys. In *The Farm* (1997, p. 74), a primly clothed farm girl, a tight sweater form-fitting her huge breasts, looks dreamily down at a picked flower and a folded paper, suggesting a barnyard romance to come. In *Dogwood* (p. 70), another painting from the same year, two girls from this corn-fed species seem to be gathering flowers in a burgeoning landscape. But one girl, who burrows earnestly in the soil between her parted thighs, has crossed her bare legs over those of her country playmate, with results that evoke the robust vulgarity and erotic earthiness of Courbet's lesbian scenes. Currin's unabashed delight in breasts and in "women as sex objects," as the phrase goes,

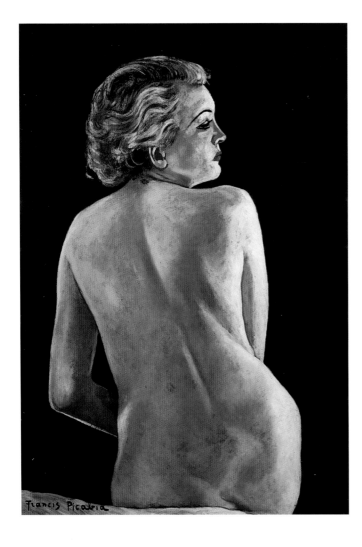

Francis Picabia
(French, 1878–1953)
Nu de dos, 1942–44
Oil on board
mounted on wood
41 1/4 x 29 1/2 in.
(104.7 x 74.9 cm)
Courtesy of Michael
Werner Gallery,
New York and Cologne
© 2003 Artist Rights Society
(ARS), New York / ADAGP,
Paris

reaches even hands-on extremes, as in *The Wizard* (1994, p. 60), almost the equivalent of the Fugs's crudely honest hit song of 1966, with its simple-minded, droning refrain: "Do you like boobs a lot?/(Yes, I like boobs a lot.)/Boobs a lot, boobs a lot./(You gotta like boobs a lot.)"

In these days of gender awareness, it is of course as easy to accuse Currin, as it is Renoir, of gross sexism; and his work has elicited its own share of feminist outrage. In 1992, writing in the *Village Voice* about his first one-man show at the Andrea Rosen Gallery, Kim Levin first quoted the relatively objective description offered in the press release ("Paintings of old women at the end of the cycle of sexual potential . . . between the object of desire and the object of loathing"), and then added, "Apart from that, they're awful paintings. Boycott this show."[6] But if Currin usually depicts women as grotesquely ripe for plucking or grotesquely over the hill, his fascination with these sexual stereotypes is too easily explained as the attitude of all "male pigs." It should be remembered that the same infatuation with surrealistically deformed and eroticized female anatomies can be no less a driving force in the work of female artists, such as Lisa Yuskavage, who has also spawned a breed of humanoids concerned only with their efforts to look like swollen Barbie dolls. Yuskavage and Currin, in fact, were classmates at the Yale School of Fine Arts, both getting their M.F.A.s there in 1986. That they arrived at comparably grotesque female fantasies should certainly indicate that these synthetically distorted visions of American womanhood are highly topical cultural issues, transcending the artists' own sexual appetites.[7] Nevertheless, Currin could not be clearer about the way in which his own libido has piloted his art. In a long statement published in 1993, he asserted that "painting has always been essentially about women, about looking at things in the same way that a straight man looks at a woman."[8] And further on, he becomes even more explicit: "When I hold a brush, it's a weird object . . . as if part of the female sex has been

taken and put on the end of this thing that is my male sex to connect with a yielding surface." (If Picasso could speak from the grave, he might say the same thing.) Currin's candor in revealing that his work is primarily rooted in heterosexual desire is refreshing. Tossing political correctness aside to make room for truer, baser instincts, he says: "I paint women and that's what my work's about."[9]

If many of these women seem the progeny of locker-room daydreams and porn magazines, others seem to have been born from the old-master DNA Currin is always collecting in the museums. In fact, separating these two major sources of his invention may be beside the point, since his fusion of venerable past and vulgar present comes out as a perfect hybrid that lives in both worlds. To be sure, the collision of naked, real-life women and old-master

Frank Frazetta
(American, b. 1928)
Sun Goddess, 1970
Oil on academy board
20 x 16 in. (50.8 x 40.6 cm)
©1970 Frank Frazetta

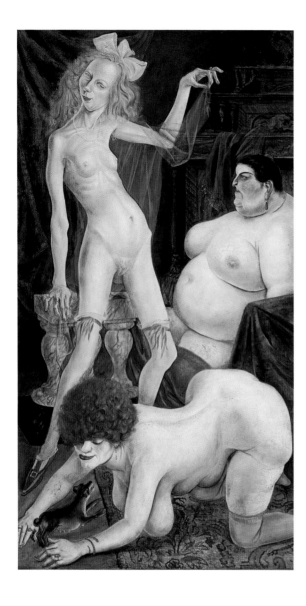

Otto Dix
(German, 1891–1969)
Three Women, 1926
Oil on canvas
71 ¼ x 41 ½ in. (181 x 105.4 cm)
Courtesy of Galerie
der Stadt Stuttgart
© 2003 Artist Rights Society
(ARS), New York / VG Bild-
Kunst, Bonn

abrupt contrasts of old and new, creating instead fluid metamorphoses that circulate through many unlikely image banks. Peter Schjeldahl succinctly pinpointed this disquieting phenomenon in Currin's work: "It's that 'old' and 'new' are exhausted categories. The past is present now."[10]

So it is that the proliferation of "ideal" nudes (although some may still keep on their bras and panties) from 1998–99 takes us on a seamless round-trip from pinups and fashion models to the lofty heights of, among others, Cranach and Botticelli. As for the latter masters, not to mention the pages of *Vogue,* they seem to have prompted Currin to create another, complementary race, whose salient features are no longer gigantic, spherical breasts and inert, clumsy postures, but slender, elegant bodies frozen in balletic poses. Currin knows his old masters inside out, and I was once able to enjoy with him a personal tour of his favorites at the Metropolitan Museum of Art. Of course, I was looking for specific sources that could have prompted his figural fantasies. His awe before the precious varieties of blue in the robes of Gerard David's Madonnas or the bravura rendering of shimmering lace in the tunic of El Greco's *Cardinal Guevara* (which, in fact, might have inspired the looser, brushier rendering of contemporary clothing in many of Currin's recent genre scenes) seemed beside my point. I was hoping rather that he would navigate me to the odder Renaissance anatomies I had imagined would be perfect grist for his mill. Happily, he did. The Northern Renaissance schools were particularly fertile, not only in his predictable love for Cranach's *Judith with the Head of Holofernes,* with its sharply defined contours that left no doubt about the strangely twisted deformations of the heroine's body, but in his fascination with a work by a far less famous artist, Cornelis Engebrechtsz, in whose *Crucifixion* (p. 20) the agonized nude bodies of Christ and the two thieves offered a vocabulary of knotted limbs and torsos that can be recognized immediately in Currin's stockpile of weird anatomy. And crossing the Alps to Italy, I

nudes is hardly new to Western painting; witness Goya's recasting of a Titian Venus as a sexually liberated maja stripped of clothing, or Manet's reincarnation of the same prototype as a Parisian courtesan, or, closer to the present, Otto Dix's Germanic fusion of Cranach's Venuses and Eves with Weimar Republic whores. Nevertheless, Currin's absorption of the old masters is far more slippery than these

registered his particular attraction to Piero di Cosimo's *Hunting Scene,* a vision of a primitive state of civilization populated by satyrs and savage men and women whose active, foreshortened bodies, with their gnarled silhouettes, look far closer to Northern than to Italian ideals of beauty. Currin was also freshly excited about the cramped and twisted body of Christ in the Met's newly acquired *Deposition* by Ludovico Carracci. And in the nineteenth-century galleries, Currin focused enthusiastically on the nudes of Corot and Courbet, seeing them as supine hills and valleys of flesh, bearing out his assertion that, for Courbet, landscape and woman were equated.[11] It's a point that he continued to make in his art, as in *Nude on a Table* (2001, p. 107), in which we can survey, starting with the feet at the bottom of the bed, the mounds and hollows of a reclining nude whose genealogical table would include porn photos, the view between parted thighs in Courbet's notorious *Origin of the World,* Ingres's odalisques, and Mantegna's famous foreshortened Christ. The breast-shaped lemons and a candelabra of three exhausted candles, dripping with wax, also mix modern and old-master erotic symbols.

From such image banks, especially those culled from Renaissance art, Currin found the anatomical inventions he could translate into modern American womanhood. In a 1996–97 sequence of what look like fashion shoots, each model seems both contemporary and ancient, with pagan sexuality startlingly relocated in the present tense. *Pelletiere* (p. 65), a memory of one of the artist's high-school classmates, and *Ann-Charlotte* (p. 10), a memory of a famous fashion model of the 1970s, are both frozen in the act of dressing or undressing, making one think that Botticelli's Venus had been caught doing a striptease. In *Heartless* (p. 72), the golden dress has a heart-shape cut-out that unexpectedly offers a peekaboo of the model's breasts. In *The Cripple* (p. 73), the sick joke of *The Invalids* is seen in a macabre variation: a smiling, full-breasted American beauty, with a cascade of perfect hair, must support

herself with a cane. In fact, the bizarre undercurrent of medical handicaps casts a grotesque pall on these anatomies, as if the corporeal fictions of Renaissance nudes, with their attenuated limbs and sinuous torsos, were to be explained factually by a diagnosis of rickets or scoliosis.

By 1998–99 these contemporary women could shed their bras and skin-tight dresses entirely, time-traveling more clearly to the "ideal" nudes of the museums. With opaquely abstract monochrome backgrounds, many of them solid black, they echo a familiar Renaissance format used by, among others, Botticelli and Cranach, a format which, like the fashion photographer's, forces us to concentrate on the fluent, wiry perfection of the figures' silhouettes.

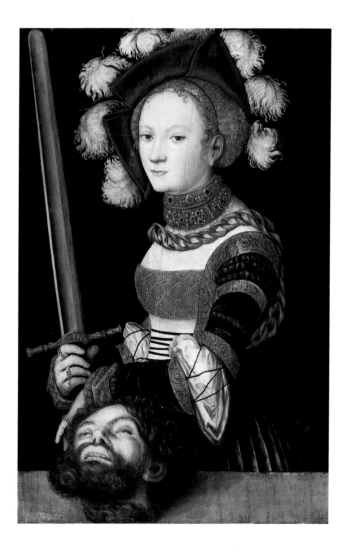

Lucas Cranach the Elder (German, 1472–1553)
Judith with the Head of Holofernes, c. 1530
Tempera and oil on wood
35 ¼ x 24 ⅜ in. (89.5 x 61.9 cm)
Collection of the Metropolitan Museum of Art, New York, Rogers Fund, 1911
11.15

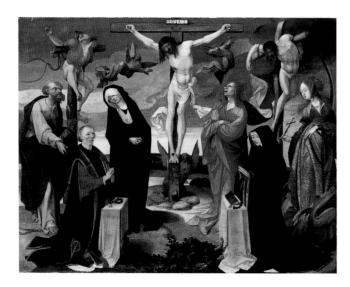

Cornelis Engebrechtsz
(Netherlandish, 1468–1527)
*The Crucifixion with Donors and
Saints Peter and Margaret,*
c. 1525–27
Oil on wood
24 ¼ x 35 ¼ in.
(61.6 x 89.5 cm)
Collection of the Metropolitan
Museum of Art, New York,
Gift of Coudert Brothers, 1888
88.3.88

In *Three Friends* (p. 88), one feels that the three goddesses in a Cranach *Judgment of Paris* have been abandoned by their heterosexual juror and left to their own devices. But this sexy trio is also a riff on a drawing by Hans Baldung Grien of three lewd, naked witches, one of whom exposes her foreshortened bottom. In Currin's retake of such beauties and monsters, a curious foreplay is introduced, including gentle touches, unraveled golden hair, intertwined limbs, and an in-your-face protrusion of buttocks and thighs that promises secrets about the next act in this perverse Renaissance ballet. More often, however, these nudes come in duos, not trios, continuing their delicate sexual provocations and slipping uncannily back and forth between memories of highly paid American fashion models with pinup girl pasts to the supernatural beauty of Renaissance Venuses or the sinister sexuality of Renaissance Eves. As twosomes, their frozen postures reach strange heights, intermingling the gawkiest, most twisted anatomies from Cranach's nudes with a wraithlike fragility that extends to the mannered gestures of their elongated fingers. But at the same time, their identities as museum-worthy erotic ideals keep shifting to images in pinup calendars. These

constant transformations pertain even to inanimate objects, so that, for example, branches of coral — in Renaissance art, usually a symbol of Christ's blood that will ward off evil — are transformed into a pink tree that looks like a prop for a modern stage set. This back-and-forth between past and present is equally disarming in a different sequence of nudes and near-nudes, now presented against pale rather than black backgrounds. Here, the postures and attributes of the crook-bearing, backpacking pinup girls in *Hobo* and *Sno-bo* (pp. 94 and 95) re-create, in a wardrobe of only bra and panties, the traditional religious figure of Saint Christopher, who fords a stream with the infant Christ on his shoulder. Similarly, in a series of female heads of 2001, classical and Christian images seem resurrected as contemporary mutations. *Round Head,* which borrows the Renaissance tondo form, is a mixture of Venus, Medusa, and the winner of a Miss America pageant. *Braces,* with a curtained background that might be host to a holy image, revives images of suffering Christian martyrs, except that this contemporary saint seems wracked by the mortification of orthodontia. *The Clairvoyant* (p. 109), with its furrowed brow and upturned eyes, combines the phoniness of a modern spiritualist with the otherworldly anguish of a German Renaissance Magdalene or Madonna. It is a tribute to Currin's thorough re-creation of his sources — whether the skin tones in 1960s girly magazines, the female demons or beauties of German Renaissance art, or even the modern revival of old-master realist techniques he had learned from William Bailey, one of his most influential teachers at Yale — that they always remain elusive, leaving subliminal memories rather than offering flat-out quotations.

This gift for total absorption of a wild diversity of images that respects neither art-historical chronology nor pecking orders of high and low art has also made it possible for Currin to reinvent the tired category of genre painting. For the better part of the twentieth century, this once great tradition, which could embrace Vermeer and Eakins, had seemed

a lost and trivial cause, firmly rooted as it was in insignificant vignettes culled from contemporary life rather than in loftier ambitions that would seek out, as the pioneers of modernism would have it, the timeless, universal truths of form and color. But by the end of the twentieth century, especially in the United States, the depiction of the ordinary facts of real people and their daily activities became a mandate for many younger artists, such as Eric Fischl, who exposes, among other things, the sexual undercurrents of suburbia. Of course, earlier in the century, artists had often registered uneventful moments in contemporary lives — think of Edward Hopper or George Segal — but Currin's new readings of American society at the turn of the millennium end up looking like the commonplace world as seen through a funhouse mirror.

Here, the usual definition of genre painting as "scenes from everyday life" goes wildly askew. Already in *Boys with a Drill,* a modest little painting of 1991, inspired by yearbook photos of what the students are up to, something is very wrong, but it's hard to say what. Two black kids are busy at a junior experiment in carpentry, but this "scene from everyday life" projects such an intensity of narrative focus that the act of drilling turns into something ominous and secret. In *Guitar Lesson* (1993, p. 38), one of the persistent themes of Western art, from Caravaggio to Picasso, becomes bafflingly strange, as we watch a middle-aged suburbanite awkwardly acquiring a new hobby. With a fixed expression of vacant concentration and with eerily skeletal limbs and fingers, she holds and strums her stringless guitar, as surprisingly flat and unreal as a cubist paper cut-out.

When Currin's bizarre race of American men enters these prosaic scenes, everyday life gets odder still, especially since some of them found their inspiration in the geeks invented for *Mad* magazine by the cartoonist David Berg. Sometimes they are seen as singles, alone and imprisoned in their domesticity. In *The Berliner* and *The Old Guy* (both 1994, pp. 56 and 59), these strange specimens of

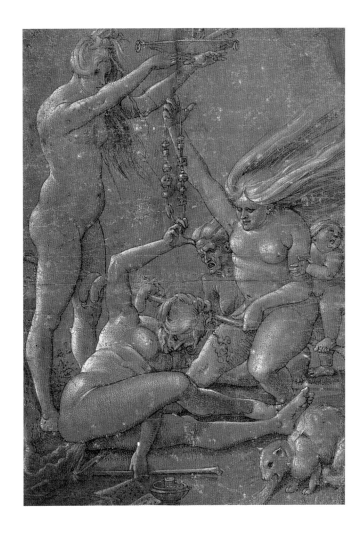

manhood, with their outsized heads, make a close-up appearance, looking as if they came not from Currin's earlier high-school graduation photos, but rather from a later phase of American education, perhaps from some out-of-town college yearbook. Holding dishtowels or seated at a silent dinner before a bowl of pasta, they seem to have taken over the roles of suburban homemakers, right down to their immaculate clothing. Their shirts and collars are fresh and white; their sweaters feature geometric patterns as tidy as their wall-hangings. At times, these rural intellectual types find the women of their

Hans Baldung Grien (German, 1484 – 1545)
The Witches, 1510
Monochrome print, two plates (gray and black)
14 7/8 × 10 3/16 in. (37.8 × 25.8 cm)
Louvre, Paris, Collection Edmond de Rothschild, bequeathed 1935
© Réunion des Musées Nationaux / Art Resource, New York

dreams and end up rhapsodically as the nerdier half of an ideal pair, introducing a theme of lovers' bliss explored by Currin in a series of variations of 1993–95. His matchmaking is predictably askew. As in earlier Renaissance traditions that caricature mismatched couples (old and young, beautiful and ugly), he dreams up unlikely combinations — a brooding thinker with a sluttish blonde; a teenager in a bathing suit with a dandified country gentleman; or a would-be bride and groom who look more like father and daughter. Moreover, despite their ostensible embraces, these lovers occupy separate worlds, each immersed in private thoughts and each averting the other's gaze. And often our vantage point is warped, as if we were looking up at a movie from the first row. In fact, these couples seem to replay the tear-jerking finales of classic movie formulas, when the lead actor and actress, towering above us as the music swells, are finally united, silhouetted against a glorious harmony of blue sky and white clouds.

With his usual ability to sound other chords of visual memory, some of these canvases look like willfully awkward reincarnations of the virtuoso painting traditions that run the gamut from Tiepolo, another one of Currin's old-master enthusiasms,[12] to such American illustrators as Howard Chandler Christy. *Twenty-three Years Ago* (1995, p. 61) sums up these many strange liaisons. Here we become Peeping Toms, stealthily observing from behind a rear view of another odd pair of embracing lovers — a nude young blonde and a freakishly dressed country spiff, sporting a striped jacket and a shirt with huge polka dots, clothing more suited to a clown than to an impassioned lover. And, true to the artist's word, the glorious sky seems to quote satirically Tiepolo's celestial skyscapes.

Currin's exploration of the oddities of contemporary American life kept expanding in the late 1990s. At times, he would continue his erotic fictions, as in *The Dream of the Doctor* (1997, p. 71), which at first glance looks like a cheerful visit to a rural doctor's office appropriate to a Norman Rockwell *Saturday Evening Post* cover. It quickly moves, however, into a potential X-rating, with a mannish female doctor, her closely cropped head half-concealed, applying her stethoscope to the chest of what must be, judging from the elaborate pink-lace bra that temporarily dangles over the screen, a patient whose luscious, bare-breasted body we can only imagine.

But in general, in a sequence of canvases from 1999–2001, Currin moved toward more familiar slices of contemporary society, focusing especially on the activities of well-heeled suburbanites, mostly women, enjoying their version of a good time. The results often seem to combine a Norman Rockwell scene of American felicity with what Goya might have produced, had he been resurrected in a posh Connecticut town and asked to update his *Caprichos,*

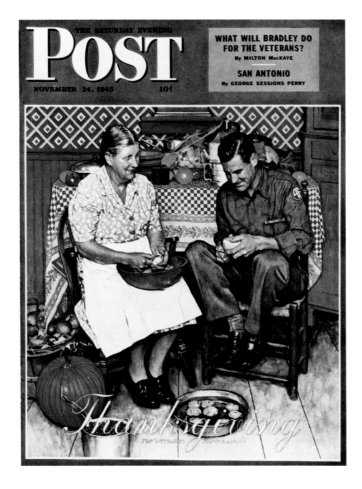

those biting commentaries on the follies of Spanish society. Old, rather than middle-aged, women dominate *The Activists* (2000, p. 101), in which we see almost a parody of small-town law and order, with a convention of aging locals, led by a very senior citizen, arguing for some neighborhood cause. More often, though, the scenes are of leisure, pleasure, and consumerism, as in *The Consignment Shop* (2000), where an immaculately groomed housewife has gone antiquing and scrutinizes an old glass vase that may soon be in her shopping bag. Mainly, women dominate these scenes, evoking a cast of happy newlyweds who have just settled into all the comforts money can buy. Occasionally they join the significant men in their lives for, say, a close-up at a buffet table or a meal at *Park City Grill* (2000, p. 97), whose title refers to a generic, upscale restaurant in a Utah ski resort where the most joyful of young and sophisticated blondes can click white-wine glasses with their perfect JFK look-alikes. And in one painting, *Homemade Pasta* (1999, p. 92), we even find a same-sex couple — sleeves rolled, aprons in place — who are working together in the kitchen to prepare the inevitable gourmet meal and who reflect recent sit-com tolerance for the more prosaic facts of gay American life. Rockwell's *Home for Thanksgiving* has been brought up to date.

As with the nudes, these genre scenes seem to be branches off many traditional trees. One thinks not only of Rockwell's cheering, hyperrealist narratives, but of countless scenes of comparably uneventful episodes that may take place in the privacy of a kitchen or living room or in the public spaces of a cafe, the kind that artists recorded everywhere from seventeenth-century Amsterdam to nineteenth-century Paris. But of course, Currin again views these vignettes of modern life through a distorting lens that emphasizes, to the point of caricature, how weirdly unnatural our world has become. A perfect example is *Stamford After-Brunch* (1999, pp. 2–3), which captures the giddy camaraderie of what appear to be three wealthy suburban housewives who, without their husbands, are filling out their post-brunch afternoon by telling hilarious tales, drinking more white wine, and, most peculiar, letting all their hair down by smoking cigars and — who knows? — confiding sexual secrets. Through the picture window, a snowy winter landscape is disclosed, a bone-chilling view that makes the interior comforts of heat and lightweight clothing look all the more unnatural. We are close here to the kind of bizarre, almost surrealist contemporary America that has captured the imagination of many film directors. *Stamford After-Brunch*, in fact, might almost be a still from Ang Lee's *Ice Storm*, a reconstruction of 1970s America that exposed the underground sex lives of adults and teenagers in a prim and wealthy Connecticut suburb during a severe winter storm that forced its residents indoors. A similar fascination with the strange rituals and fashions of American life from earlier decades can be seen in Todd Haynes's *Far from Heaven* (2002), a movie that, like Currin's art, is charged with a sinister nostalgia, in this case for the stylized dramas and decor of the 1950s, as defined in the films of Douglas Sirk. Or, there is Alan Ball's HBO series *Six Feet Under,* in which the old-fashioned soap-opera format is now used to scrutinize the grotesque public and private lives of what purports to be just another American family. Like these directors, Currin looks at the crumbling myths and icons of twentieth-century America, revealing, as in a warped looking-glass, their bizarre surface and their dark underside.

Olivia Birkelund, Barbara Garrick, Patricia Clarkson, and Julianne Moore in Todd Haynes's *Far from Heaven*. © Focus Features, 2002 All rights reserved.

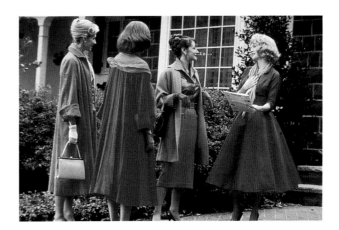

NOTES

1 Roberta Smith, "Realism Considered from Three Angles," *New York Times*, August 1, 1977, p. C25.

2 Parallels with Goya have already been suggested in a review of Currin's London ICA show (1996): Waldemar Januszczak, "Goya of the Golden Girls," *Sunday Times* (London), January 21, 1996, pp. 14–15.

3 Jeffrey Deitch, *Post Human*, Pully/Lausanne, Switzerland: FAE Musée d'Art Contemporain, 1992.

4 Robert Rosenblum, "John Currin," *Bomb*, no. 71 (spring 2000), pp. 74–78.

5 As quoted in Jerry Saltz, "The Redemption of a Breast Man," *Village Voice*, November 17–23, 1999, p. 77.

6 Kim Levin, *Village Voice*, April 21, 1992, p. 77.

7 The relationship of Currin's and Yuskavage's work, together with that of another woman artist, Catherine Howe, is discussed in Barry Schwabsky, "Picturehood is Powerful," *Art in America* 85, no. 12 (December 1997), pp. 80–85.

8 Included in "Cherchez la femme PEINTRE! — A Parkett Inquiry," *Parkett*, no. 37 (1993), pp. 146–47.

9 Ibid., p. 147.

10 Peter Schjeldahl, "The Elegant Scavenger," *New Yorker* (February 22 and March 1, 1999), pp. 174–76.

11 In "Cherchez la femme . . ." (note 8), p. 146.

12 For Currin's comments on his conversion to the Tiepolos at the Metropolitan Museum and his way of parodying their heavenly buoyancy, see his interview with Keith Seward *in John Currin: Oeuvres/Works: 1989–1995*, Limoges: Fonds Régional d'Art Contemporain du Limousin, 1995, p. 45.

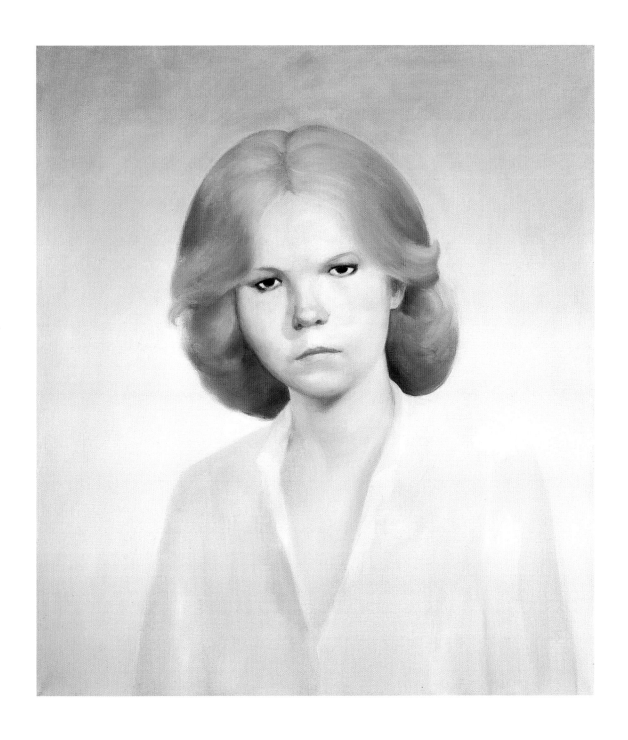

Mary O'Connel, 1989

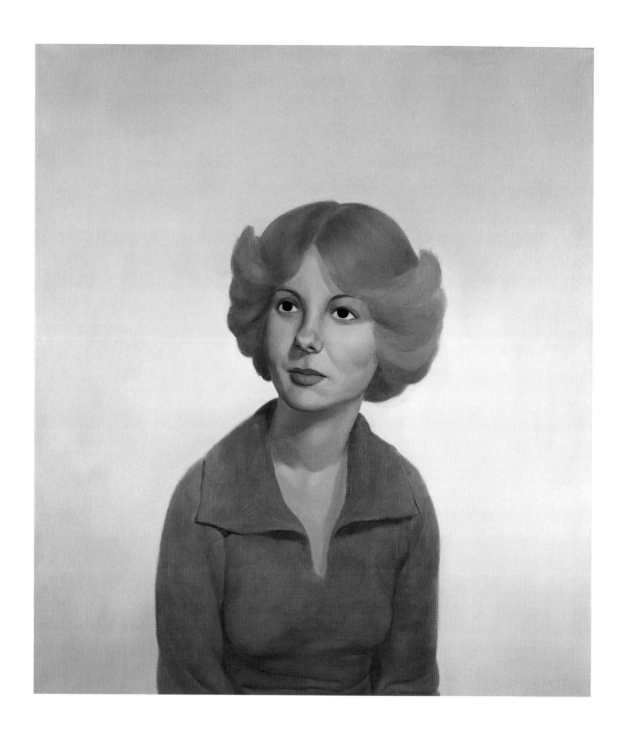

Untitled, 1990

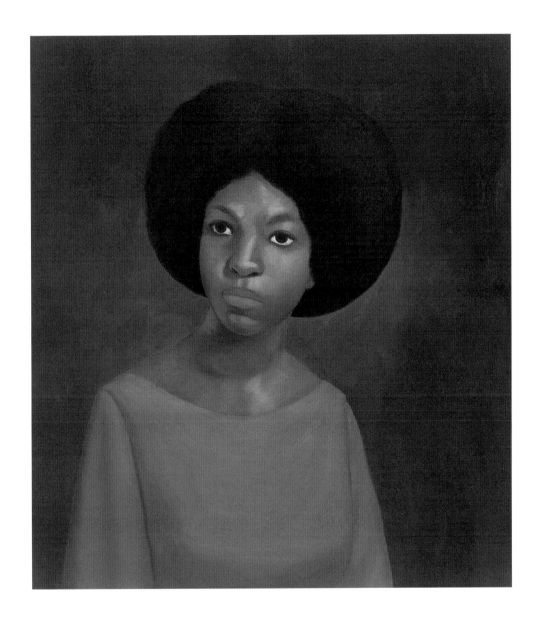

Untitled, 1990

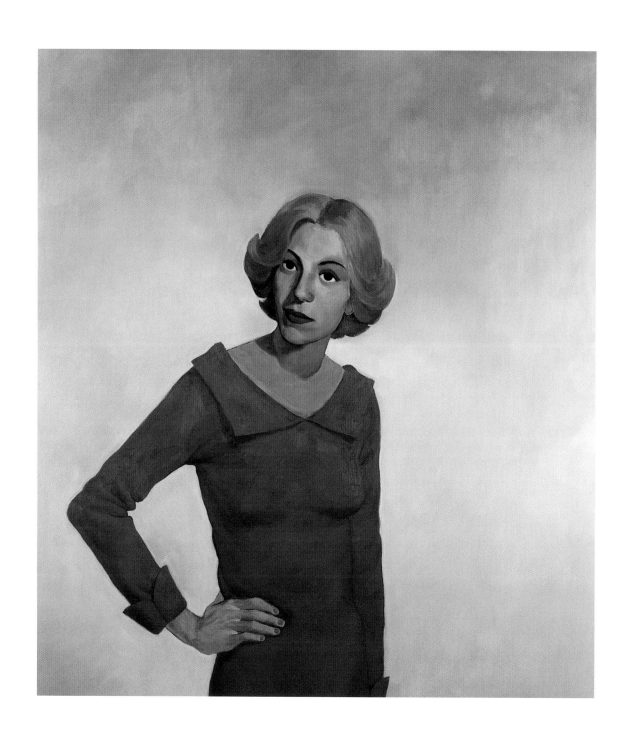

Shakespeare Actress, 1991

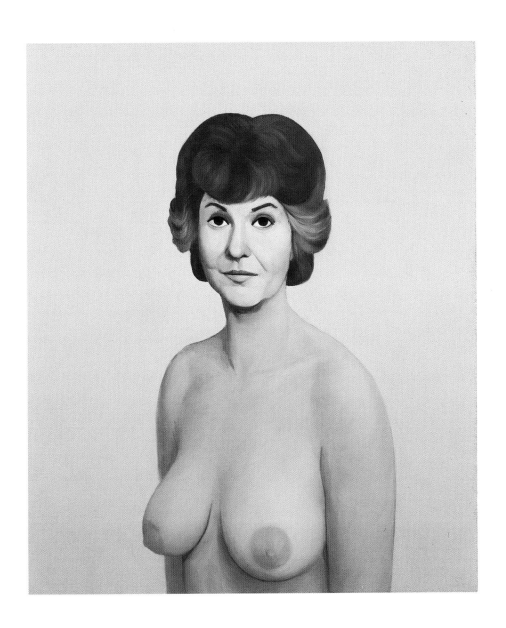

Bea Arthur Naked, 1991

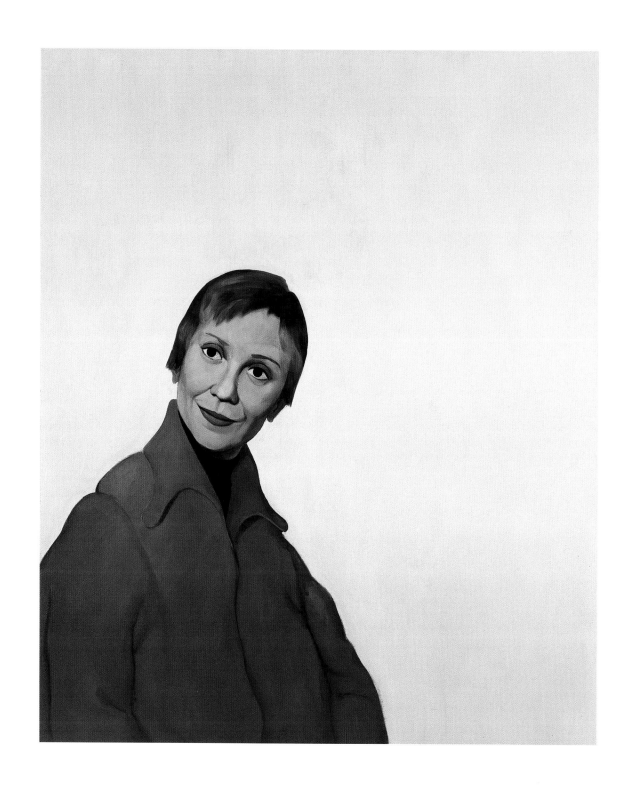

The Moved Over Lady, 1991

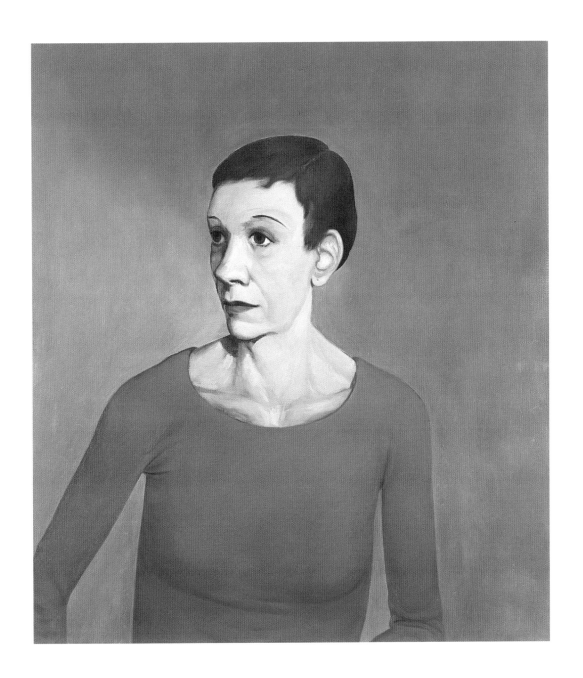

Jamita, 1991

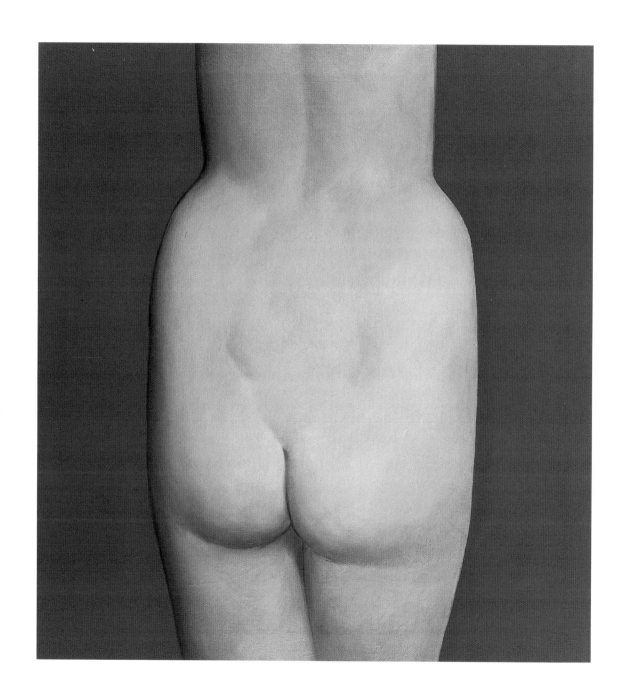

Bottom, 1991

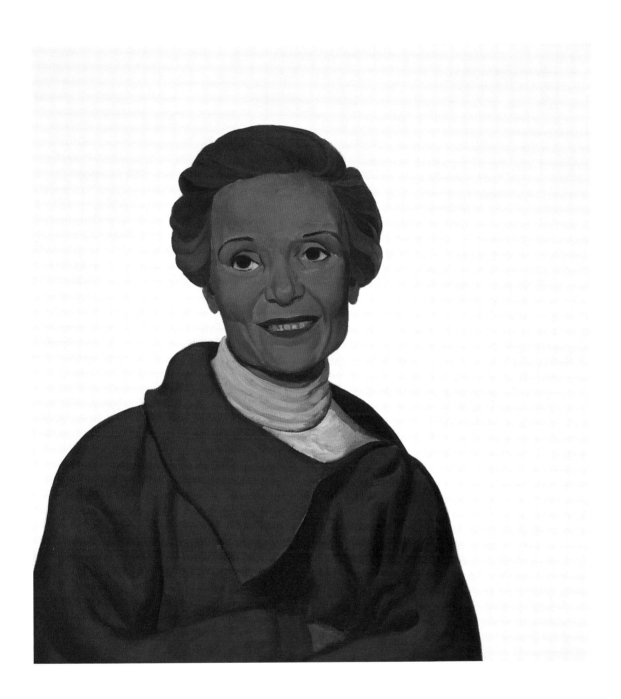

Brown Lady, 1991

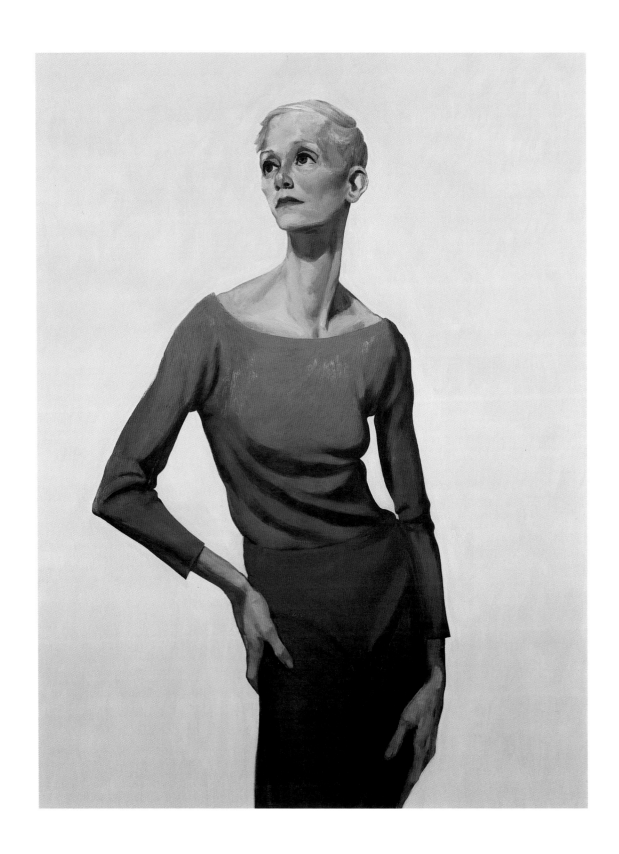

Skinny Woman, 1992

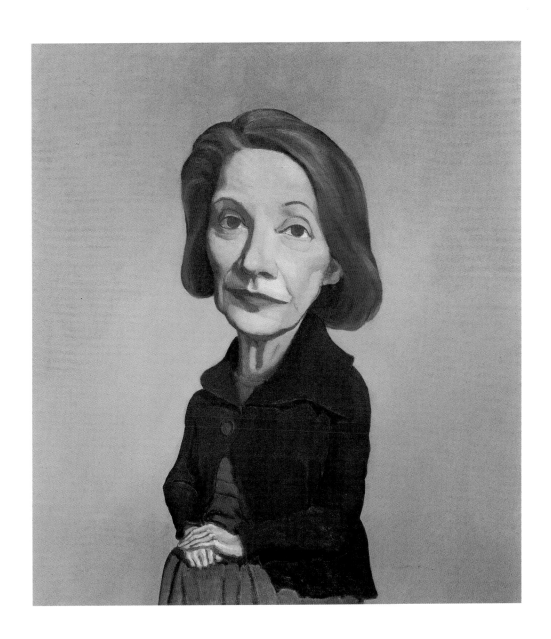

Nadine Gordimer, 1992

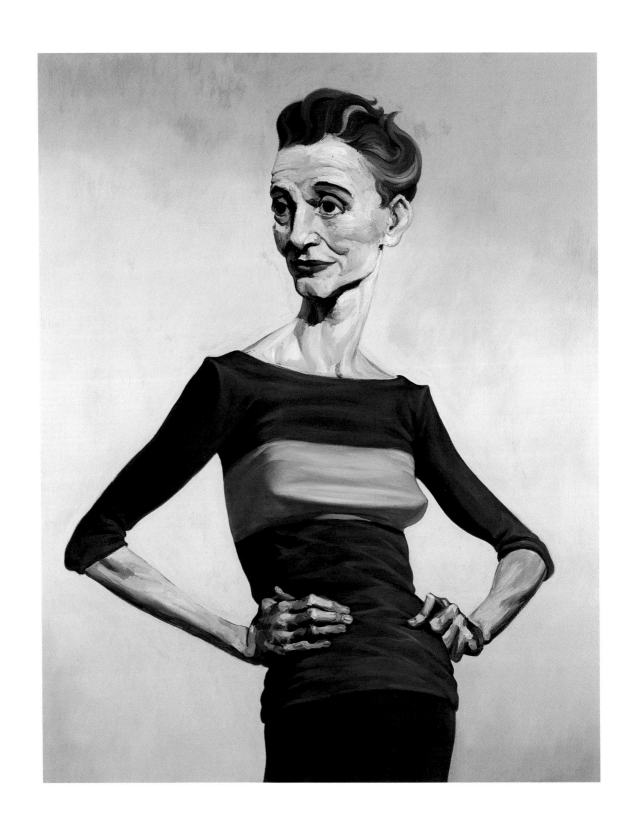

Ms. Omni, 1993

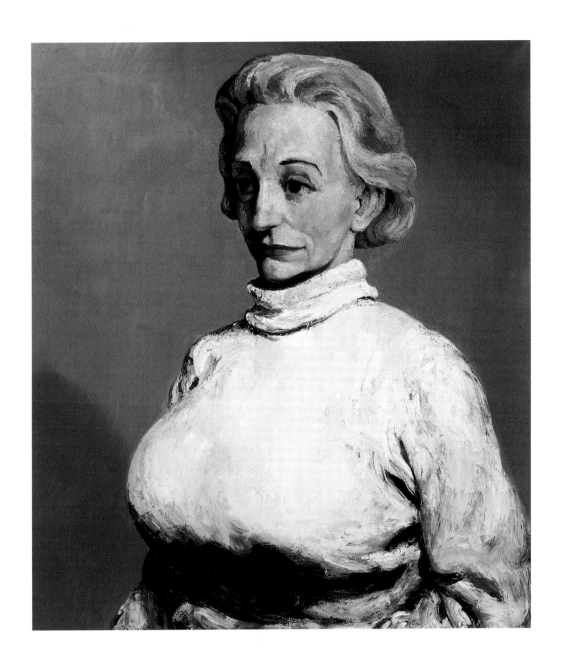

Big Lady, 1993

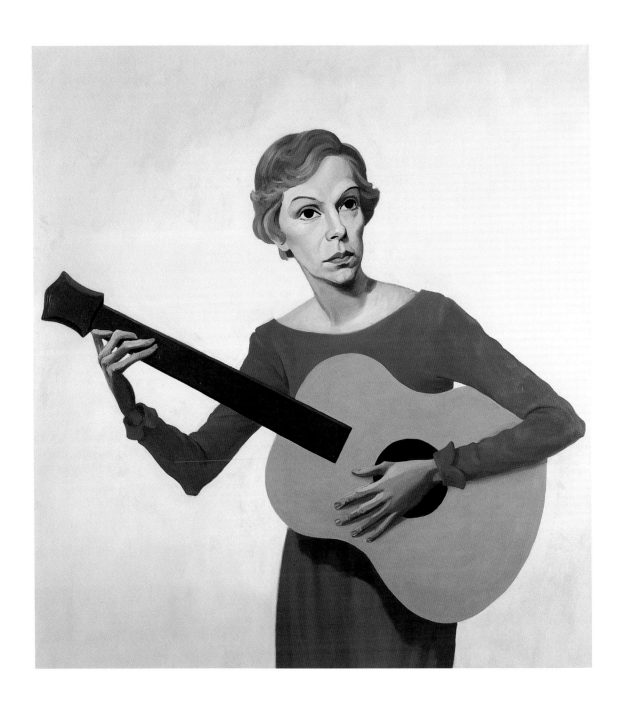

Guitar Lesson, 1993

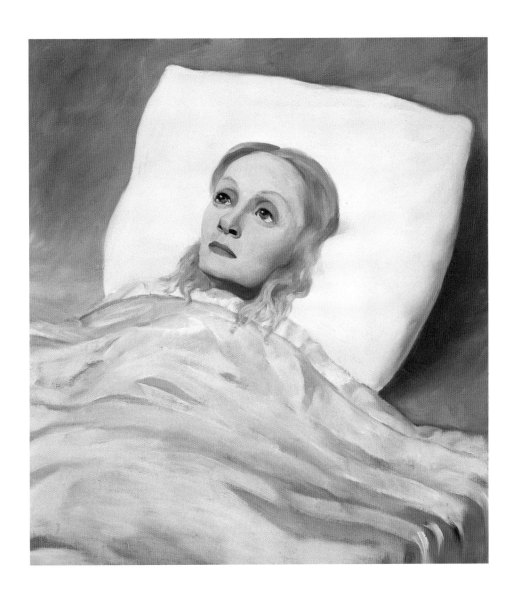

Girl in Bed, 1993

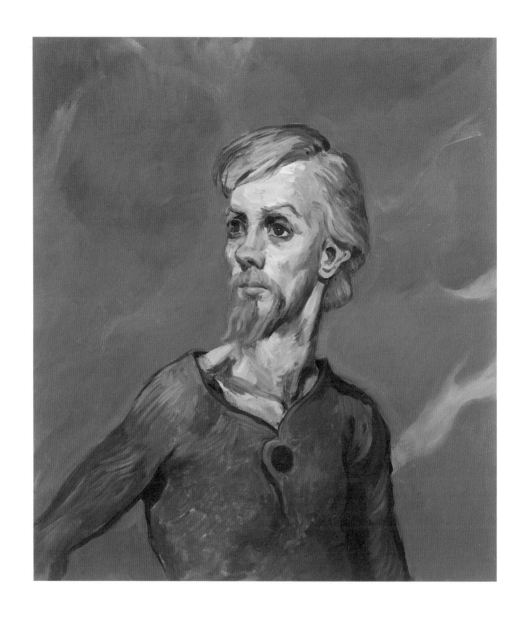

Portrait, 1993

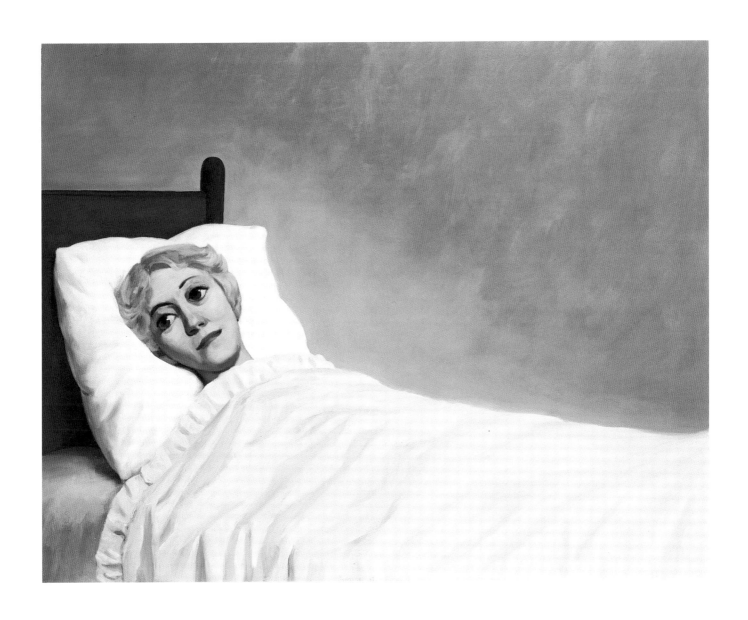

Girl in Bed, 1993

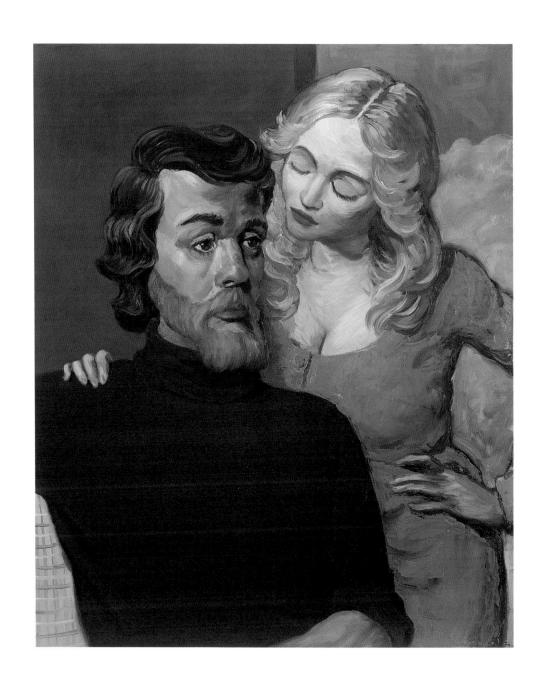

Lovers, 1993

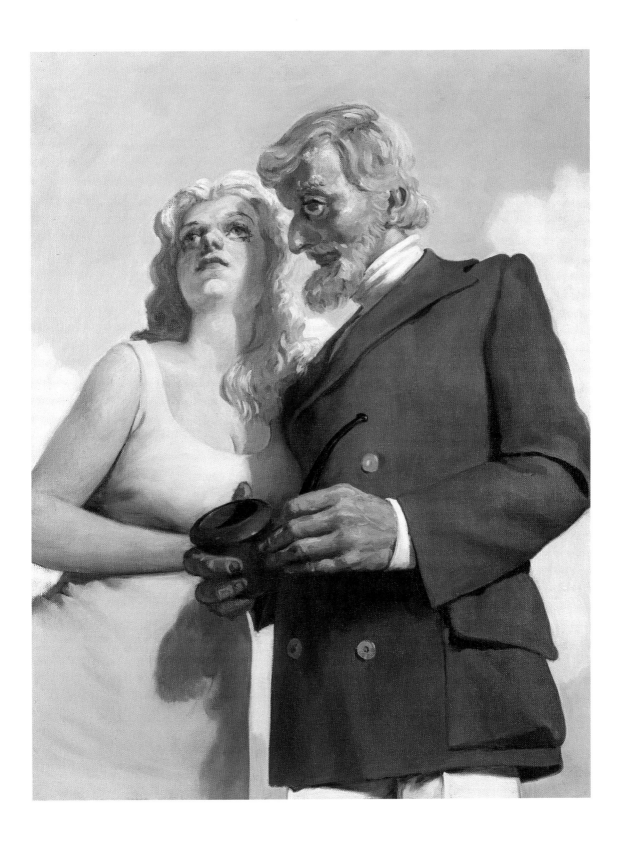

Lovers in the Country, 1993

The Neverending Story, 1994

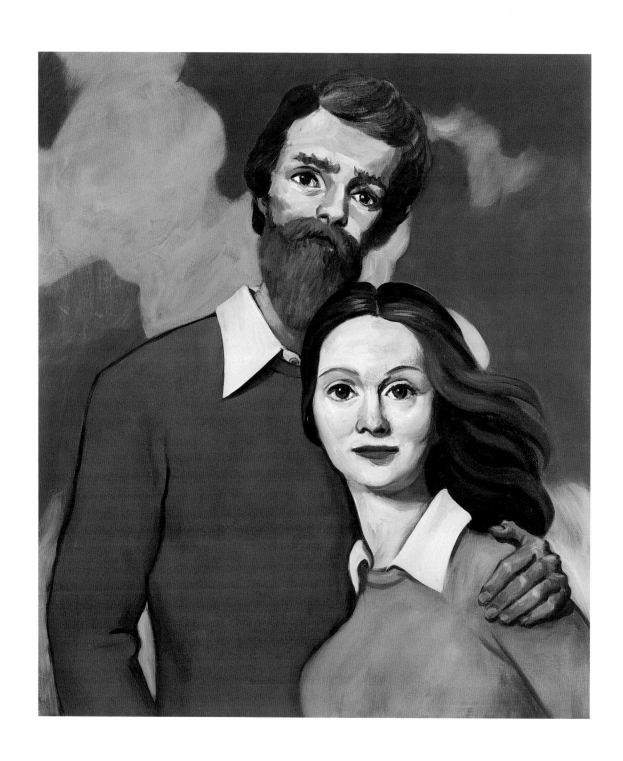

Happy Lovers, 1993

The Lovers, the Invalids, and the Socialites

Staci Boris

ohn Currin tends to rant. He has no patience for the things that irritate him: political correctness, art that strives to change him ("why doesn't a director just direct his movie and not try to improve me?"), video art, the expected, and most people. He channels his aggressive energy into his paintings, which are, like his arguments, well conceived, sophisticated, layered, and always delivered with a strong dose of humor. Over the past decade his paintings have garnered high praise and virulent condemnation, a range of reactions Currin welcomes, and, in fact, strives to elicit. A provocateur, Currin has stated outright that he is "not in love with the viewer. There is an assumption that the artist is supposed to put [his] arm around the viewer and step back to admire this thing that [he's] made. I always thought it should be the opposite; it should be an antagonistic relationship."[1] Currin's early depictions of middle-aged women and pinup nudes based on pornography illustrate this clearly, especially as they coincided (and clashed) with the first surge of explicit multiculturalism and so-called political correctness in the art world.

Currin's use of traditional method and genre — painting and a form based on portraiture — has proven as unsettling as his imagery. As an ambivalent Brian d'Amato wrote in *Flash Art*, "their ordinariness is somehow comforting and at the same time an unexpected thing to put in a good gallery."[2] Unlike other agitators, such as Sigmar Polke, Martin Kippenberger, and Jeff Koons, whose output has been varied in terms of media, Currin has consistently made modestly sized oil paintings of women, men, and couples. His virtuosity with a brush and his steadfast devotion to the medium separate him from the aforementioned group of irascibles and, to some, make his work reactionary rather than radical. Currin's conversations are more likely to include mention of Tintoretto, Hals, Velasquez, Courbet, and Picasso than LeWitt and Nauman. He seeks inspiration more from the Metropolitan than the Museum of Modern Art and sees painting as special, mysterious, even magical, maintaining that an image is transformed when translated into oil paint. Currin also believes that painting embodies a level of authority that can make people uncomfortable.

Given this conviction, Currin has managed to render something challenging and new in the most conventional of packages. He is an astute observer of human nature, delighting especially in the strange and the wicked. He is also a clever borrower of imagery from pop culture, situating himself insistently within a postmodern context. Despite his aesthetic predisposition to traditional forms, Currin is thoroughly engaged with the cultural output of the moment: video games, Hollywood movies, popular magazines, and the trappings of high society and high fashion. He understands what we want to see and either gives us the opposite or throws a grotesquely exaggerated version of what we think we want back

in our faces. Yet his love of paint, his physical engagement with the medium, and his reverence for the venerable practitioners who have come before him are all at the core of his practice. Over the past decade Currin's manner of painting has evolved from an intentionally "bad" technique with a limited palette to a more complex, if more traditional, system of underpainting, modeling, and color application. Three intriguing and enigmatic paintings of the 1990s — *Happy Lovers* (1993), *The Invalids* (1997), and *Buffet* (1999) — provide a compelling illustration of this development, and of the great cultural and emotional range Currin achieves through his chosen language.

*H*appy Lovers (p. 46) is the first painting Currin made in a series of lovers, a group of works from 1993. Portraits of middle-aged women painted in earth colors from 1909 Picasso paintings ("good for constructing an object," Currin says) immediately preceded the lovers. In these works, the women's sculptural heft contrasted with the monochromatic backgrounds and served, for Currin, as pictorial allegories of his concerns at the time: abstraction versus figuration, male versus female, acceptable versus bad taste. To counter what he felt were conflicted personages in these complex paintings, Currin split the intense focus on one figure into a couple. Bearded men (or "human billy-goats" as critic Waldemar Januszczak has described them[3]) and sexy babes (although in *Happy Lovers,* a rather square version) replaced the women whose isolated identities are intricately woven into the fabric of the paintings.

Currin completed *Happy Lovers* in three days. He painted in a deliberately brisk and aggressive fashion — black outlines with filled-in color, a proplike beard attached to a woman's face (the man started out with the face of opera diva Maria Callas), oversized opaque eyes, flat images reminiscent of thrift store paintings. Currin wanted the painting to look like it was put together in pieces, that it could fall apart if shaken too vigorously. Like DeKooning's

slashing brushstrokes, and perhaps his vicious women, *Happy Lovers* was the manifestation of Currin's expressionistic impulses — for him, at that time, "anger, depression, and misery." His calculatingly slapdash approach represented a deliberate attempt to make painting look different, reflecting the influence of idiosyncratic artists like Francis Picabia and Kippenberger. It was also a decidedly rebellious act, and Currin derived great pleasure and excitement from what he saw as a transgression.

Happy Lovers looks less like an old-master work than a standard, posed photographic portrait taken at a local Sears department store. Currin apes this middlebrow convention, even including his own rendition of a fake-sky background. The two lovers are tenderly united, the woman's body fitting perfectly into the man's embrace, her head resting attractively against his chest. Sporting monochromatic crewneck sweaters with starched white collars primly peeking out, this happy couple dresses alike, in perfect harmony. The woman seems to be lifted straight out of an old Clairol print ad, but her face was actually inspired by a fashion portrait of an older woman from a 1950s *Classic Photography* magazine.

Currin's archetypal man — a tall, lanky, bearded, academic type — makes his first appearance in this painting. Slightly modified in subsequent paintings, he is a guy that seems lucky to have the attention, if not the utter devotion, of the pretty girl next door or the scantily clad co-ed as in *The Neverending Story* (1994, p. 44). In 1993, Currin wrote that the imagined women who become his paintings are at a stage of "impotence, inactivity, suspension," and he appropriates this "stagnation as a mirror of how [he] feels all the time." He went on to assert that his most "sexist-looking paintings are in fact [his] most anti-male" and that if he "could ever bring [himself] to paint men, they would be big and ugly and abject."[4]

The couple's pose was taken from a rum ad in a 1970s *Playboy* magazine (a good source for poses of couples that say "a guy with his chick"). The perspective is a bit off, as if it was a snapshot taken on

a hill by someone standing below the couple. Though the perspective is not as dramatically skewed as it is in *Lovers in the Country* (1993, p. 43), the viewer still has the sensation of looking up adoringly (or is it jealously?) at the towering couple against a lovely blue sky with a burst of puffy white clouds, the billowing forms of which suggest a nude woman — a subliminal addition, perhaps, on Currin's part. Though one might expect a depiction of a happy couple to evoke passion, chemistry, or sexual energy, this one is still, as if the couple were frozen in time. One may sense that Currin is mocking this straitlaced, content pair who reek of conventionality, but there are also hints that he is belittling his own envy. It is a comedy of manners — a critique of conformity with ambivalent undertones. One hates the thing one desires.

Currin regularly uses photographic images that embody these kinds of contradictions as sources for his paintings. He mainly looks to magazine advertisements, mail-order catalogues, and stock photographs in which people are always smiling, often exhibiting unbelievable joy for ordinary situations. These second-hand images follow commercial photographic conventions and are, by definition, artificial and manipulated. They set up a fantasy or a fiction, in the former for themselves and in the latter for us. These types of images attract Currin and, in painting them, he adds his own layer of fantasy. Unlike traditional photographs, there is no external reality in Currin's works, no real version outside of the confines of the canvas — much the allure of photography, pornographic photography in particular. His imaginative hybrids underscore the personal nature of his imagery — his "fanciful composites . . . speak . . . about their author's tastes, desires, and projections."[5]

Many artists using photography in the past two decades consciously referred to painting or history paintings specifically, vying for a place in the pantheon of more "respected" media while simultaneously expanding the reach of painting. Several of these artists have been included in recent exhibitions examining current painting practices.[6] The large staged or manipulated photographs of Jeff Wall and Andreas Gursky, for example, fit within both contexts. Currin, however, mimics the most aesthetically bereft photographic forms — the department store photo, the 1970s print ad or catalogue image, and the yearbook photo — in *Happy Lovers* and other early paintings. In doing so, he is not considering photography alongside painting, but rather in the service of what he considers a more substantial art form.

Currin painted *The Invalids* (p. 50) four years after *Happy Lovers*. Certain similarities are evident — both pairs are huddled together and classically centered in the middle of the canvas, parts of them are painted in similar fashion, with little modeling of the bodies, liberal use of black outlines, and simplistic backgrounds that allude to a particular location outside of the painting. The source for the pose of *The Invalids* was not an image from a men's magazine or anything otherwise sexually charged, but an awkwardly drawn cartoon of two children dancing (a boy and a much taller girl) from an ad for a charitable organization such as United Way. Currin's duo is tangled in an awkward embrace that could be both erotic and poignant. The blonde in the wheelchair, straddled by the standing woman, is lost in a moment of either passion or anguish. The standing woman is either looking oddly into the distance or is noticing her badly rendered arm. There seems to be little emotional connection between the two women, as if they exist solely to be in this painting. Their arms are clasped in a way that echos the corners of the canvas, their impossible anatomy again underscoring Currin's dominion over his subjects and his ultimate control over the viewer. Though one might expect an image of two women embracing to be titillating, Currin has made this unlikely. While insinuating sexuality through the flesh colored drape, the phallic wheelchair handle, and the centrally placed,

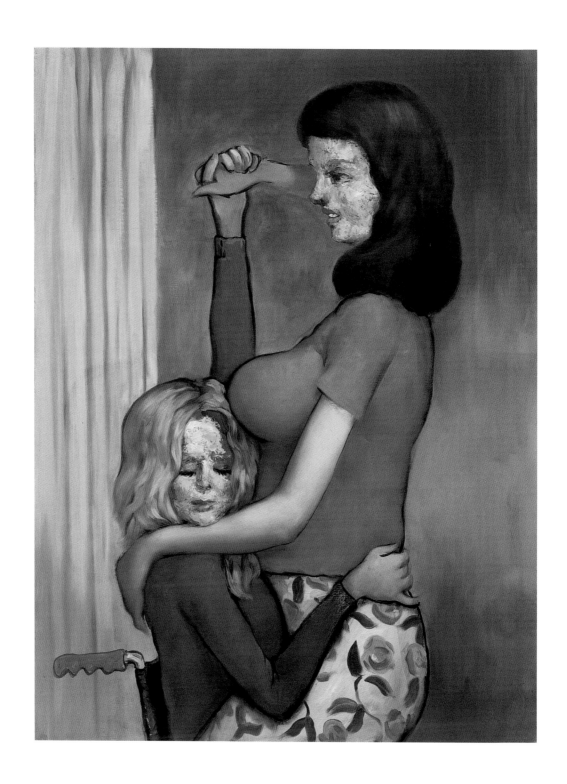

The Invalids, 1997

voluptuous breast, he thwarts this impulse by drawing our attention to the women's unsightly impastoed faces. This juxtaposition of two painting techniques is also characteristic of such works from 1997 as *Dogwood* (p. 70), *The Bra Shop* (p. 66), *Jaunty and Mame* (p. 67), and portraits like *The Magnificent Bosom* (p. 69). The women's bodies are painted with brushes in monochrome passages with a smooth finish, while the faces are thickly built up of numerous colors with a palette knife, resulting in a horrifically craggy surface. Currin maintains that these two types of paint applications symbolize different kinds of intimacy, the idealized and the real. While painting the breasts with brushes, he insists that they get better with each successive layer. The palette knife portions are conversely impossible to improve, each extra scratch or dab increasingly damaging them — a metaphor for romantic relationships, perhaps. The figures also recall the monstrous portrait of Dorian Gray, from Oscar Wilde's classic story of 1890, which becomes older and uglier with each transgression of the eternally young and ultimately damned dandy. Currin's women manifest these conflicts in that the fantasy and the nightmare become one.

Peter Schjeldahl's observation that "Currin unites extremes of low-down grotesquerie and classical elegance,"[7] seems an apt comment on the aesthetic dynamic of *The Invalids*. Despite the more disturbing aspects of this painting, one cannot overlook the presence of some beautiful and moving elements. The rose pattern on the skirt is lovingly crafted. The seated woman looks as if she was once beautiful and still retains a luscious mane of blonde hair. We can detect her moving and heartfelt expression, even through the crusty paint. Small touches such as her chin resting on the arm of her companion and her daintily extended pinky imbue this unsettling scene with bits of grace.

Another painting of the same year, *The Cripple* (p. 73), depicts a fashion model with a contorted hand and a cane. The cane, only partially visible like the wheelchair in *The Invalids,* sneaks in at the lower part of the painting. The carefree look on the model's face and her beautiful mane of hair flung perfectly to one side become her facade — she is struggling to promote a particular, and misleading, appearance. She depends heavily upon the cane; her arm is stiffly bent and her shoulder protrudes unnaturally. Currin provides an almost-perfect specimen of mainstream beauty and sexuality, yet saddles her with a deformity and a will so admirable that we cannot, at any moment, really consider her as a sex object without a nagging feeling of guilt. On the other hand, these two paintings might suggest a fetish, perhaps goading us into an exploration of private fantasy or a consideration of the hidden desires of the artist.

The *Invalids* is one of the last paintings Currin painted in his deliberately confrontational style. A work of that same year, *Heartless* (p. 72), provided him with a technical breakthrough. He modeled the figure in black and white and then layered that underpainting with color and flesh tones. Separating form and color hides the mechanics of the painting's structure and allows for a bravura performance to occur on the surface. This anachronistic technique led directly into Currin's series of nudes from 1998 to 1999. The nudes appear in different forms — individual portraits, double and triple groupings against black backgrounds reminiscent of works by Lucas Cranach or Hans Baldung Grien, and two hobos and the beautiful *Gold Nude* (1999, p. 89), against lighter backgrounds. Currin conceived of this as a procession from the ideal nude (a Venus type also recalling Botticelli) to what he considers the semisocialized hobo through the socialized or overly civilized upper-class woman one finds in *Buffet* (p. 53). This image is immediately recognizable as a caricature, with the enlarged head and exaggerated nose and jaw. The type is not dissimilar from Currin's early portrait of South African writer Nadine Gordimer (1992, p. 35), one of the few identifiable women he has painted. While Gordimer is constructed in earth tones and isolated in a

sea of dusty academic gray, the woman in *Buffet* is exuberantly painted, from her coral lips to her well-tailored green-striped designer suit. Currin has lavished attention on all parts of the canvas, from the center to the corners to the background, which is painted as if it is swirling around the figures. This is the first time he has located his figures in a chaotic space, and this movement around the painting is surprisingly dynamic.

Currin has explained this type of spatial organization, where the background is painted around the figures rather than behind them, as a way to construct a space that is painterly instead of photographic. The viewer sees everything — nothing is hidden behind anything else. The man's tuxedo does not continue behind or underneath the woman's arm. His lapel seems to be both behind her and on top of her shoulder. The energy comes both from Currin's brushy application and from how he painted the background, which is strangely on the same plane as the figure, though we are trained to see it as receding. This chaotic style recalls Venetian painting, especially the rough brushwork of Tintoretto, where space cloaks the figures, as well as the mannerist works of El Greco in which the figures seem to warp the space they occupy.

The scene in *Buffet* of privileged Upper East Side life is one that Currin has surely experienced himself — at art openings, at collector's dinners, at benefits. Along with other works of this same period, *Homemade Pasta* (p. 92), *The Consignment Shop,* and *Stamford After-Brunch* (pp. 2 – 3), *Buffet* is a parody of bourgeois leisure activities, ordinary subjects with a "slice of life" sensibility. Currin's previous works have been criticized for being banal, but such remarks referred more to form rather than to content. The character of his early portraits of women was deadpan, flat, and distant. Yet the domestic scenarios like *Buffet* and *Homemade Pasta,* prosaic in their own right, are rendered in anything but a dull manner. Most often found in the pages of literary journals, political cartoons, and printed moral para-

bles aimed at the masses, such caricatured images are rarely given the grandeur of oil painting. It is partly this tension between the image type and the style that makes these works compelling, not to mention Currin's attention to the idea of surface, both physical and metaphorical.

Buffet, like *Happy Lovers* and *The Invalids,* is not without its Currinesque peculiarities. An oddly foreshortened plate thrusts in from the lower right corner, presented by a truncated hand, making us wonder if it is the woman's hand or that of someone serving her. The plate is painted as if seen from above, yet the figures are depicted as though they were slightly elevated. The nearly translucent man contrasts sharply with the solidity of the woman's hearty face. The curved marks on his cheeks and forehead and his downcast eyes recall the faces of some of Currin's earlier male protagonists, especially the poor clown in *The Wizard* (1994, p. 60).

Currin does not include such characteristic details and eccentricities purely for his own pleasure, though one can surmise that he finds great joy in doing so. Providing an entertaining and enticing entry into the work, these odd elements are also meant to confound us — to draw us in, make us look, and ultimately force us to make conclusions about the meaning of the painting as a whole. And though we may try to resist, they compel speculation about the artist himself. There is a clear shift from Currin's paintings of the early 1990s to the current ones, a reflection, perhaps, of his changing interests and his maturation as a person and as an artist. His source material has changed from "low culture" appropriations, primarily photographic in nature, to quotations from the history of painting. And over time, his paintings have increasingly demonstrated his exceptional skill as a painter in the old-fashioned manner, articulating texture, sensuality, and luminosity. His pictorial strategies, however, as well as his concentration on recurring themes have remained consistent. Currin's painting methods and the characters that inhabit his synthetic world embody different

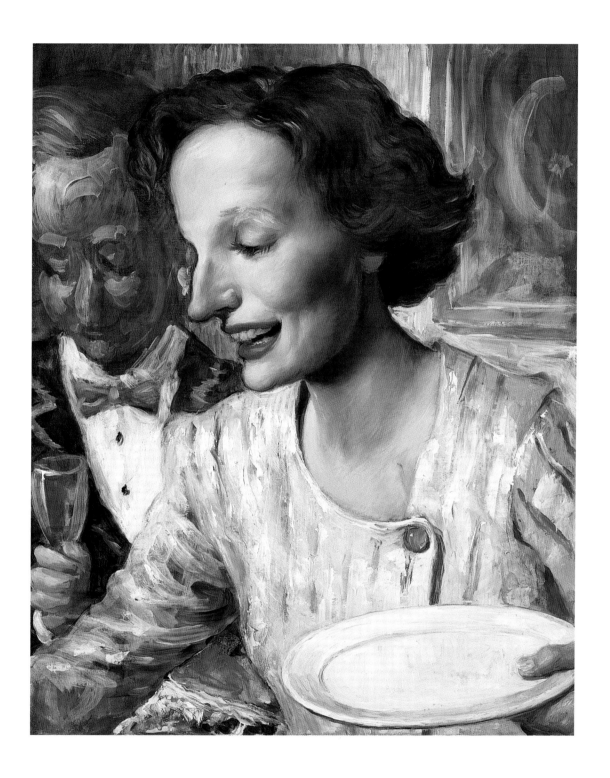

Buffet, 1999

kinds of desire and varying sentiments about their attainability. *Happy Lovers, The Invalids,* and *Buffet* address love, passion, and the riches of success — the desirability of which has made them a mainstay in the image world of the mass media. Yet the way Currin paints these ideas frustrates our customary experience of them, exposing their clichéd logic and complicating them greatly. Currin's petulant individuality combines with his exquisite skill to explore the convoluted realm of desire, recalling a host of fascinating references yet liberating us from our tendency toward a predictable response.

NOTES

1 Alison M. Gingeras, ed., *"Dear Painter, paint me ..." Painting the Figure since Late Picabia,* exh. cat. (Paris: Musée National d'Art Moderne, Centre Pompidou; Vienna: Kunsthalle Wien; and Frankfurt: Schirn Kunsthalle, 2002), p. 77.

2 In "Spotlight: John Currin." *Flash Art* 25, no. 165 (summer 1992), p. 105.

3 In "Goya of the Golden Girls," *Sunday Times* (London), January 21, 1996, pp. 14–15.

4 In "Cherchez la femme PEINTRE! — A Parkett Inquiry." *Parkett,* no. 37 (1993), p. 146.

5 Joshua Decter, "John Currin at Andrea Rosen Gallery." *Artforum* 32, no. 9 (May 1994), pp. 100–1.

6 For example, *Painting at the Edge of the World,* Walker Art Center, Minneapolis, 2001, curated by Douglas Fogle, and *People See Paintings: Photography and Painting from the MCA Collection,* Museum of Contemporary Art, Chicago, 2002, curated by Francesco Bonami.

7 Peter Schjeldahl, "The Elegant Scavenger." *New Yorker* (February 22 and March 1, 1999), p. 174.

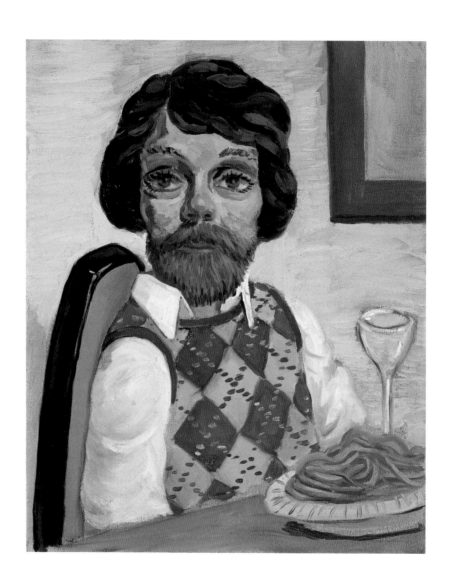

The Berliner, 1994

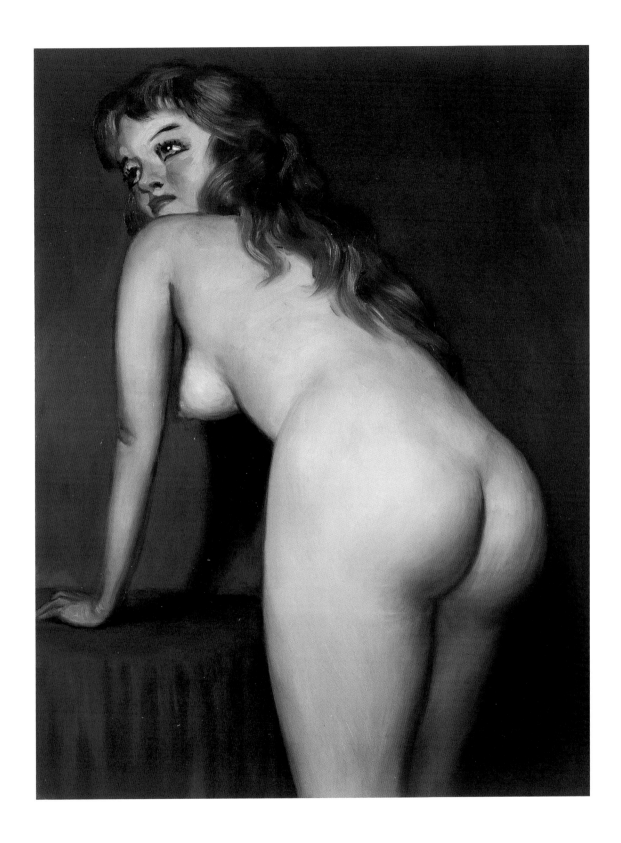

Nude, 1994

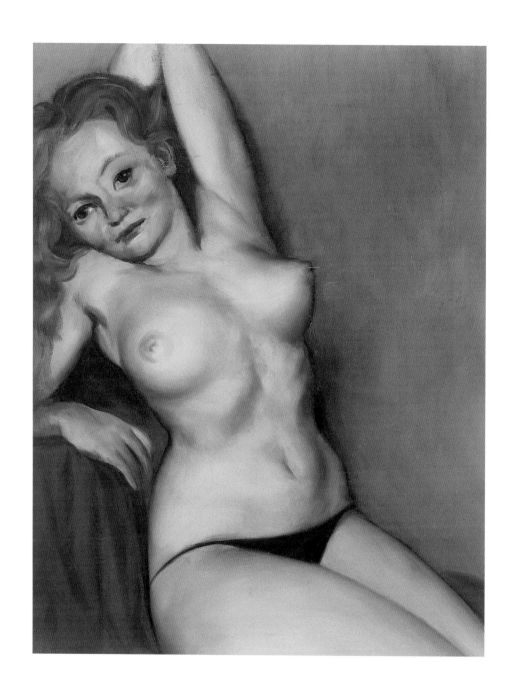

Blonde Nude, 1994

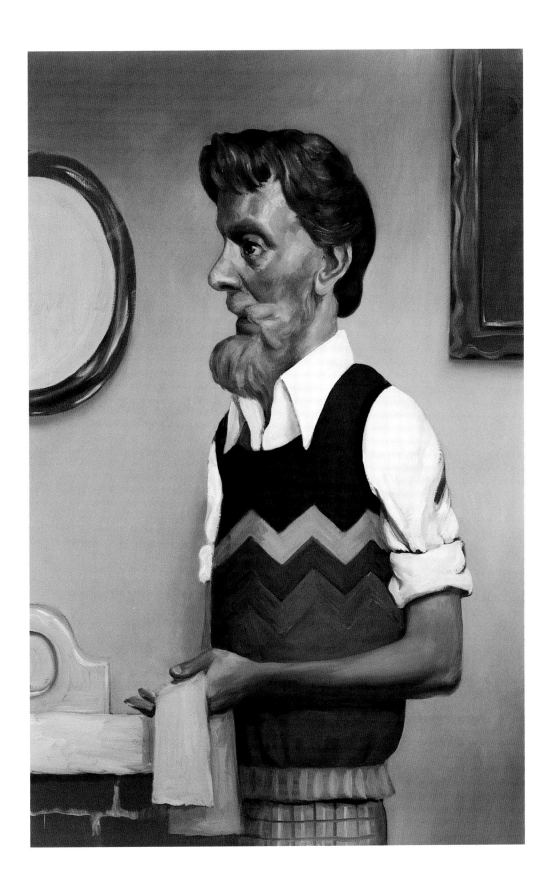

The Old Guy, 1994

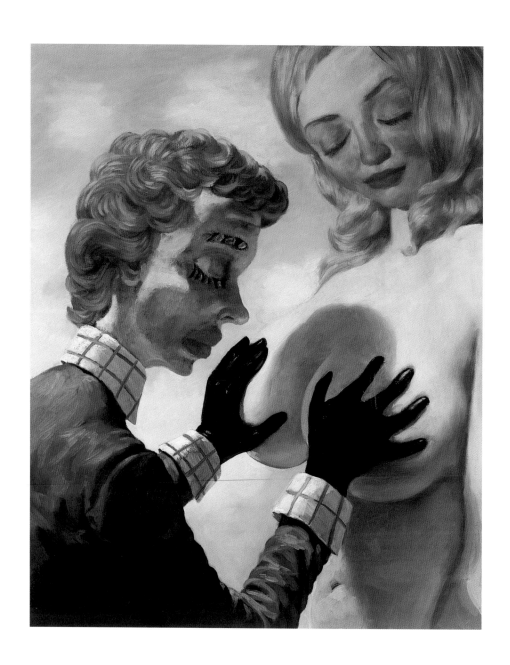

The Wizard, 1994

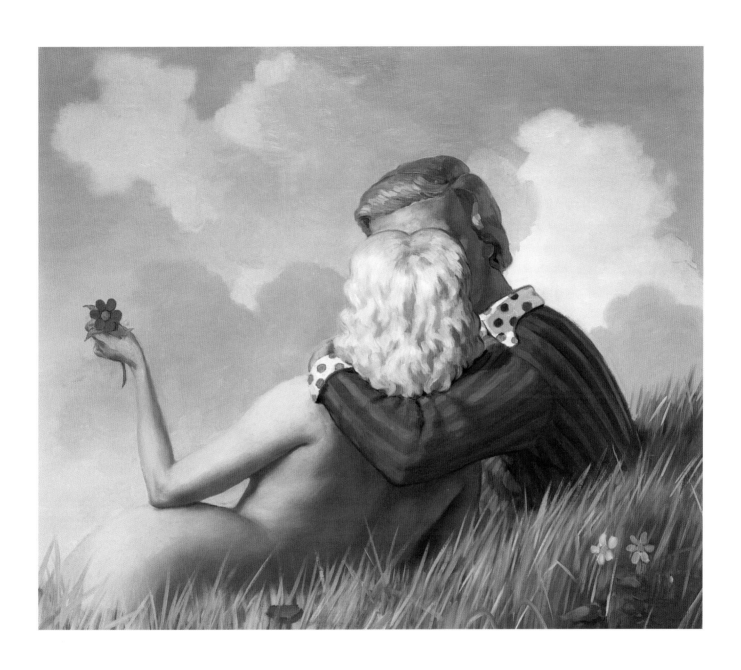

Twenty-three Years Ago, 1995

Girl on a Hill, 1995

SuperAngel, 1995

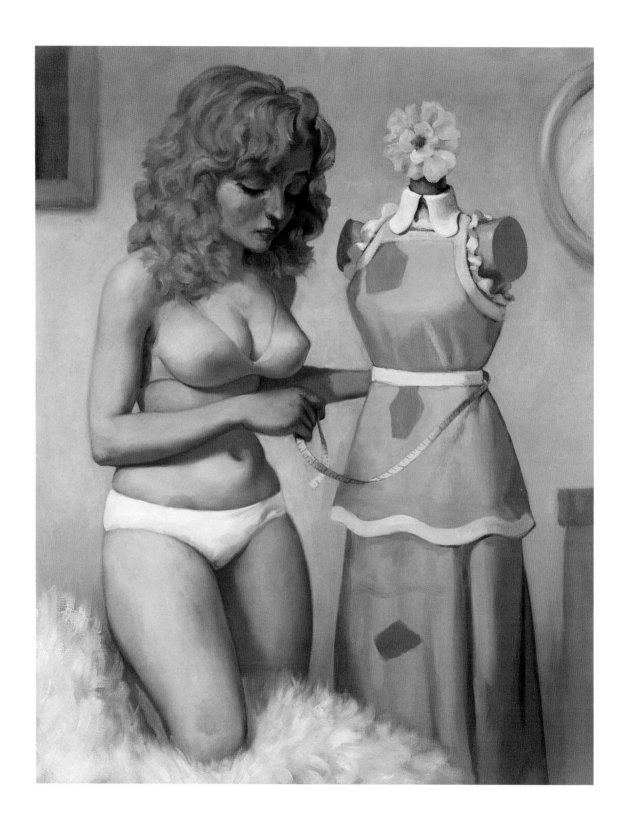

Dressmaker, 1995

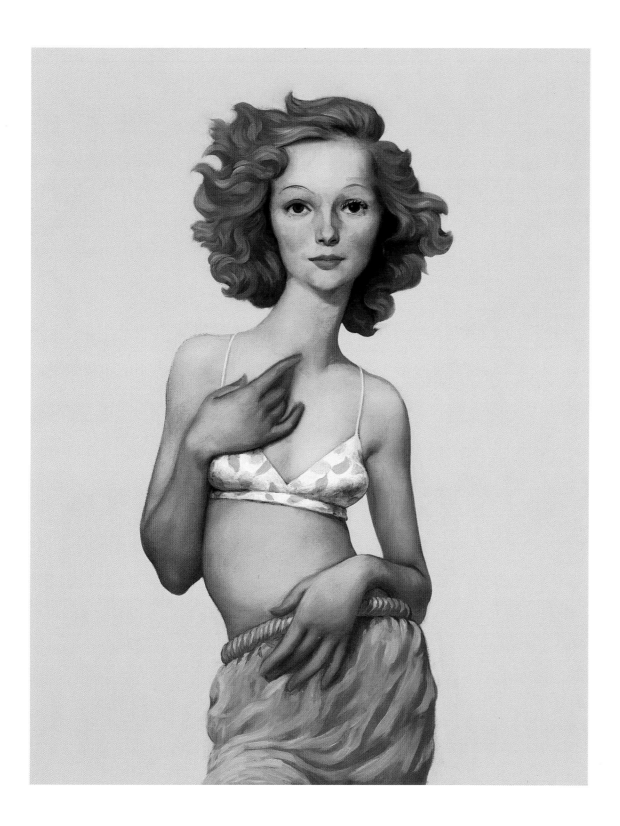

Pelletiere, 1996

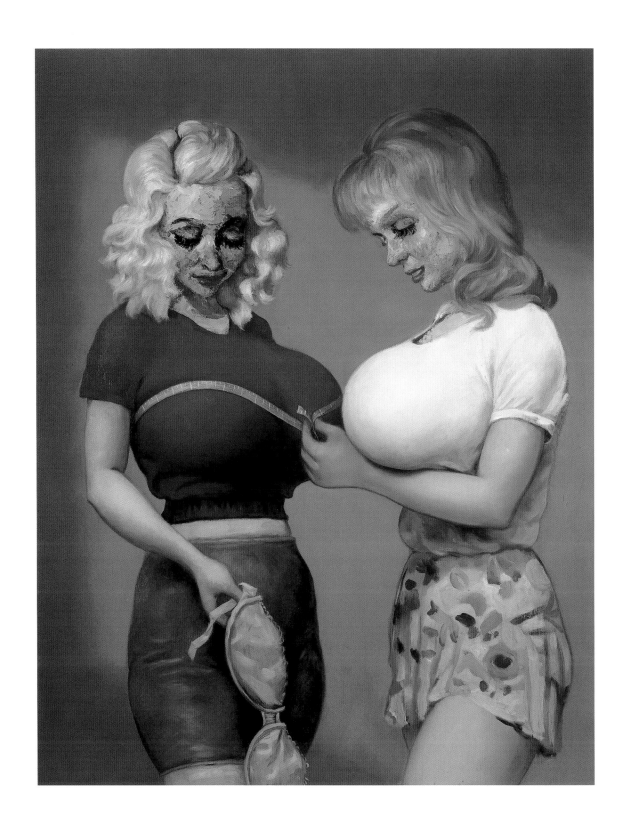

The Bra Shop, 1997

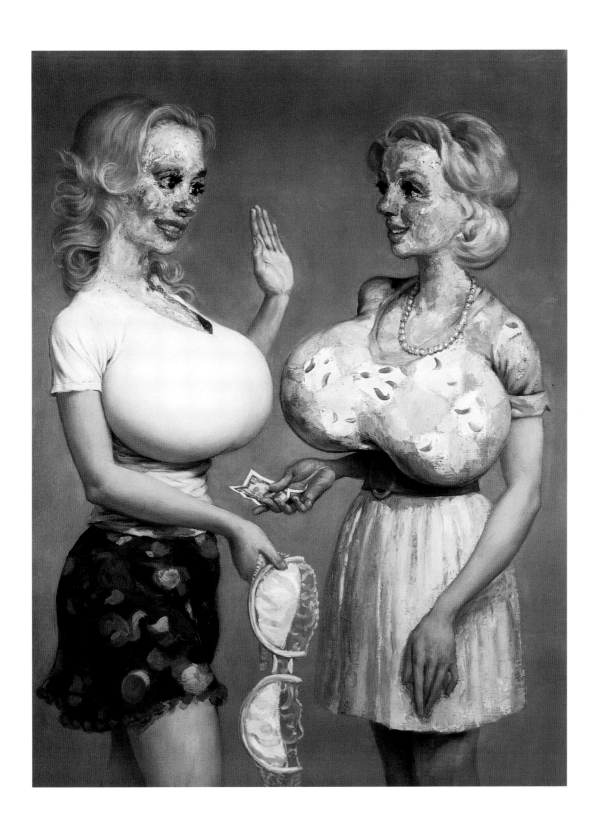

Jaunty and Mame, 1997

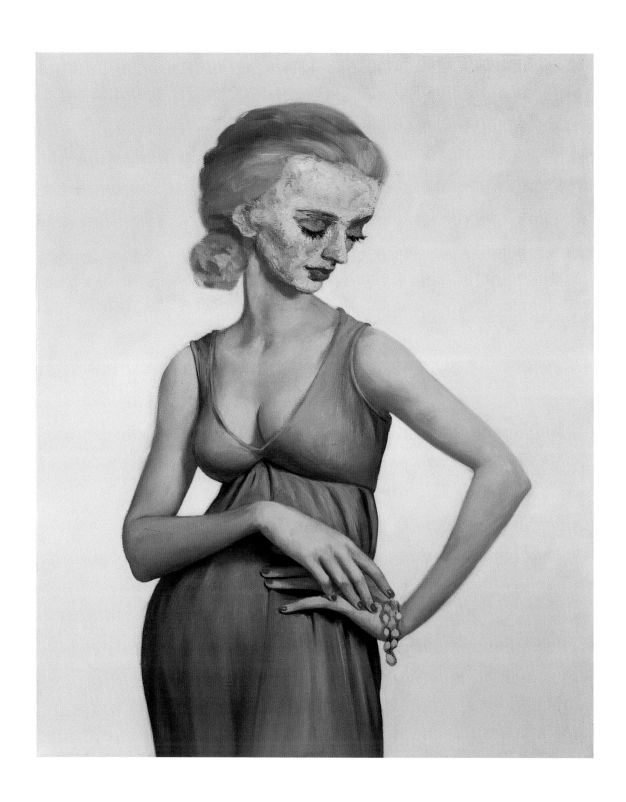

Ms. Fenwick, 1996

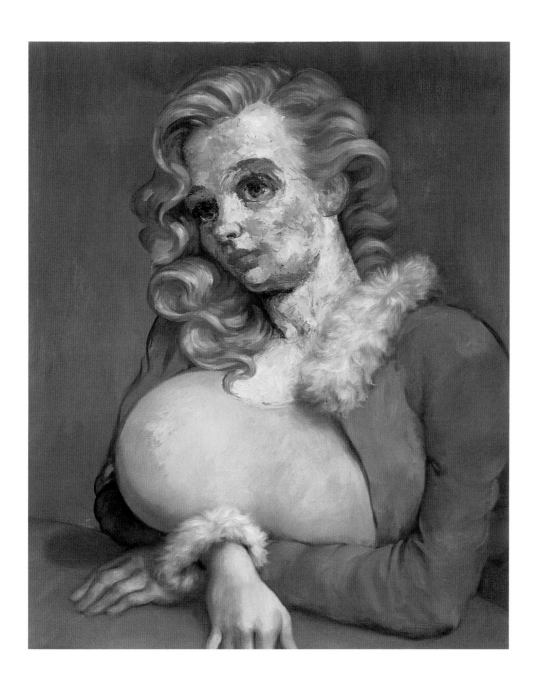

The Magnificent Bosom, 1997

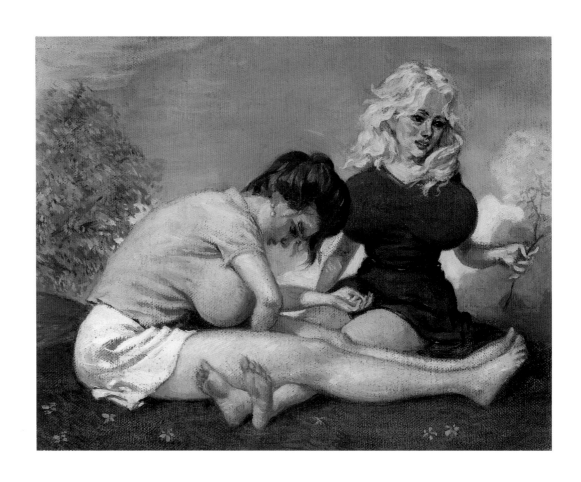

Dogwood, 1997

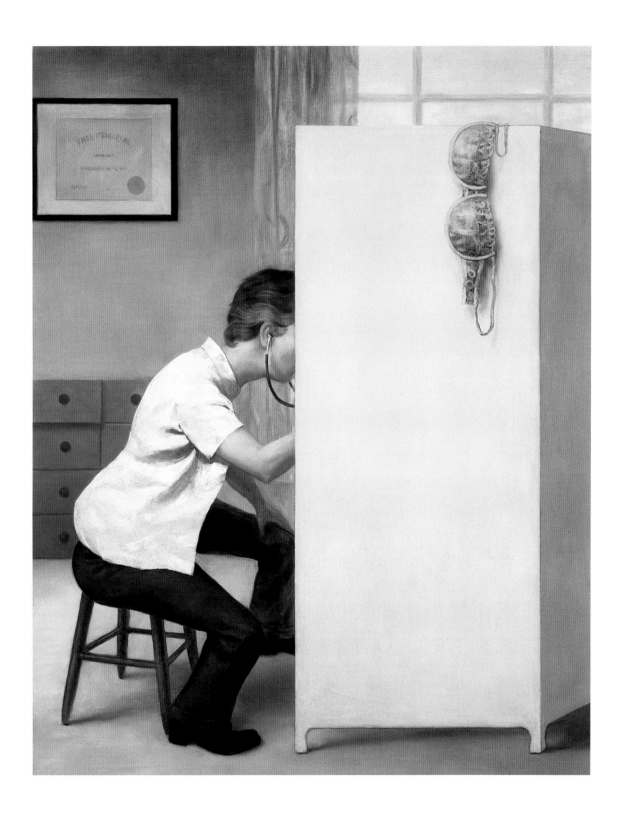

The Dream of the Doctor, 1997

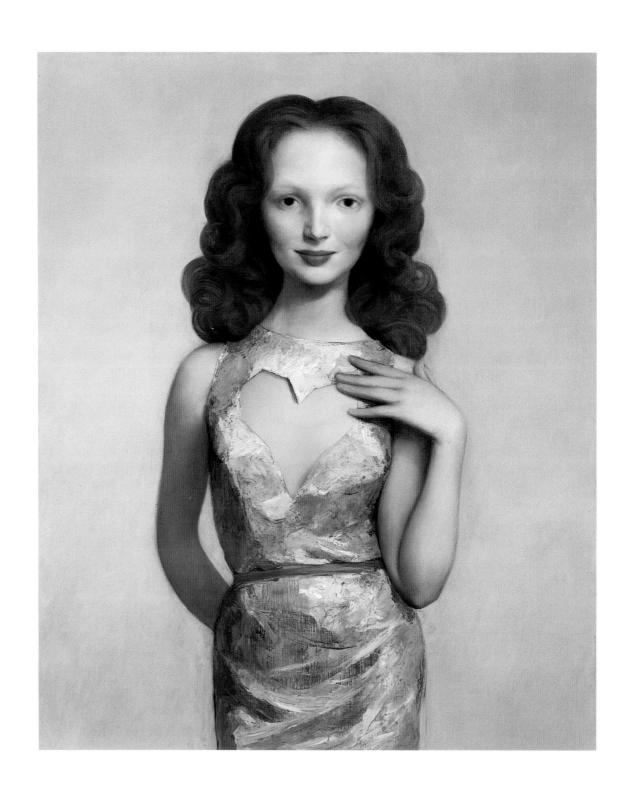

Heartless, 1997

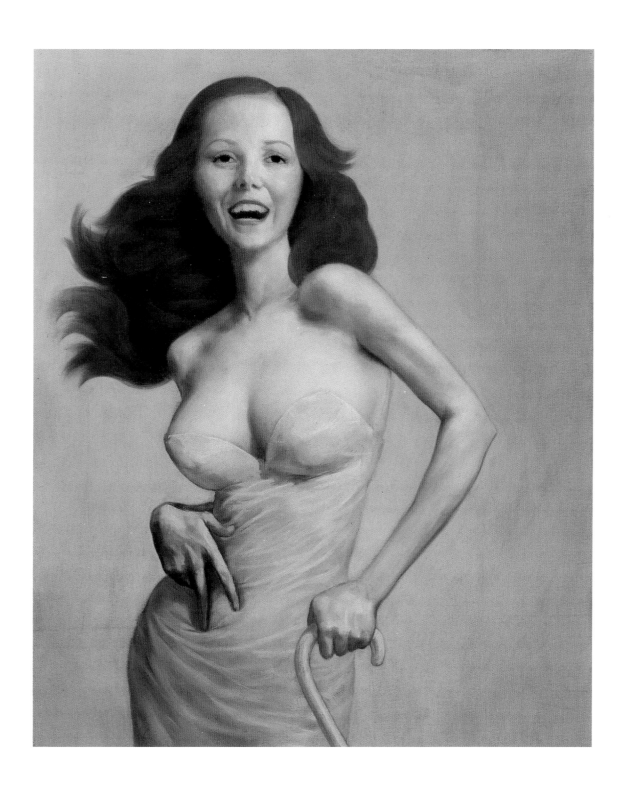

The Cripple, 1997

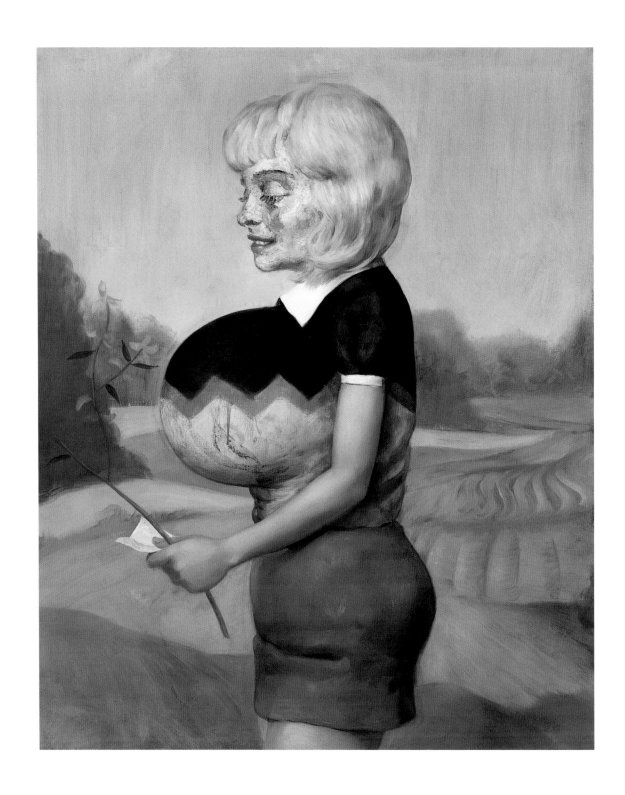

The Farm, 1997

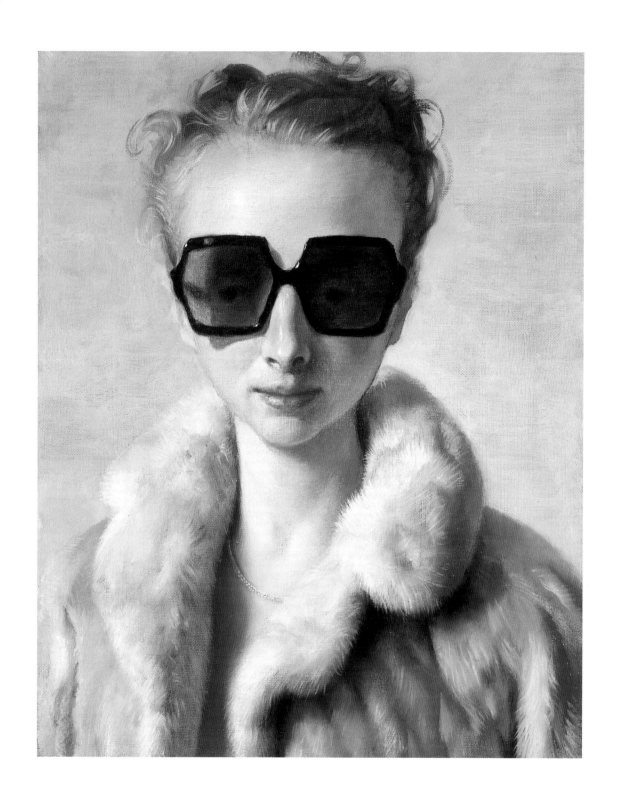

Rachel in Fur, 2002

Interview with John Currin

Rochelle Steiner

RS Your work is associated with portraits — particularly portraits of your wife, Rachel. And yet none of these pieces really look like her. It seems to me that the only true portrait you've made is *Rachel in Fur.*

JC The black background nudes (1998–99, pp. 79, 88, 90, 91, 93) were my first attempt to make something out of Rachel, to make something consciously out of my feelings about Rachel and her image. I love the proportions of her face — they tend to come out when I draw other people. I like her far-apart, drooping eyes, which are different than the eyes models typically have. Even though the faces are not hers, the whole vibe of those paintings was about getting married. At that time I was trying to get away from social-political content in my work. I like the idea of just kind of getting lost in the reverie, which makes the painting matter, makes it good, makes it great.

RS Did you work with models for the black background nudes?

JC No. Occasionally I was the model for the arms and hands and stuff like that, but obviously the breasts are just made up, and the bellies are not anatomical, they're just ways of making nice shapes on the canvas. I also thought that they would be nice with faces from fashion models, *Cosmo*-girl faces.

RS Are your features in all of your paintings?

JC Oh, yes. I always project myself on them — I incorporate my face, hands, and back in the figures. *Ms. Omni* (1993, p. 36) came out of a picture of an actress I found somewhere, a tiny little grainy picture in a newspaper, and I just loved her face. But I ended up sticking a lot of myself into its details. I basically project myself onto everything rather than reveal a lot about other people. I'm not like Alice Neel — in her paintings you really get the feeling of a particular person. The people I paint don't exist. The only thing that's real is the painting. It's not like a photograph where there's another reality that existed at a certain moment in time in the past. The image is only happening right now and this is the only version of it. To me, that's fascinating. It's an eternal moment.

RS Many of your women are very beautiful in a classic way, but many are also awkward — either they're crippled or they look as if they're ill. I'm thinking about the *Girl in Bed* (1993, pp. 39 and 41) series and *The Invalids* (1997, p. 50)*,* of course, but also paintings like *Portrait of Chewy* (2001, p. 102), in which the woman is bald. Why doesn't she have hair? Is she supposed to look like a cancer patient?

JC Well, I liked the roundness on top of her head. I started with a face I saw in the theater — she's an actress. As I painted she got younger and younger and her face changed. She got a different mouth and my nose. She started having that kind of survivor look you see in pharmaceutical ads that suggests "I'm living with AIDS" or "I'm living with cancer." I know it came close to parody, but it also seemed kind of magical. That's a subtle thing, and I couldn't have intended it.

RS What about the paintings of girls in bed? Did you intend for them to look ill?

JC Actually, I really tried to make them not look sick. I wanted to make a totally passive subject. I made those paintings right after I made the middle-aged women, where the isolation of the figures against the blank background was almost like an act of violence. I also had an idea about the blank background standing for a hard-ass kind of minimalist painting. They're very male, and they seem to me to be about repressed male violence or something like that. At that point I wanted to get away from that duality of the re-pressed woman and the repressed abstract painting behind her, and make the isolation of the figure more benign. So she's been isolated by being put in bed. She's awake — she's not sleep-ing, she's not sick, she's just a completely passive isolated watcher or spectator.

RS She can't do anything but look.

JC She doesn't have any life or activity. She just looks at things. It's an allegory of what you're doing when you look at the painting. She can't sleep be-cause you're looking at the painting.

RS And what about the images of crippled women, like *The Cripple* (1997, p. 73) and *The Invalids*?

JC A lot of the women in my paintings are burdened one way or another, either psychologically or they're actually carrying some heavy thing. I re-member that at one point I was looking through some sort of underground books, like fetish comics by Eric Stanton. One of the titles was something like "Betty's Burden" or "Hampered Harriet," and I just thought what a strange idea that the turn-on is a woman who is hampered. They're fully clothed, there's no nudity or any-thing, just the idea of a hampered woman. It struck a chord with me — not that I'm some kind of creep. Maybe, partly, this imagery makes phys-ical the guilt you feel for objectifying her.

For *Hobo* and *Sno-bo* (both 1999, pp. 94 and 95) I had this idea of a sexy hobo, like one in some low-budget TV show from the 80s like *Knight Rider* or *Baywatch*. It was set in a soup kitchen, with a hilarious line of basically good-looking, sexy homeless people. And I just love that image of a kind of sexy wanderer, I guess.

RS These paintings seem more mysterious than the black background nudes, partly because the figures are veiled.

JC Well, that's it. I was interested in the silvers, the silvery-ness, and the see-through clothes. That was the big joke: it's a homeless person with beautiful see-through lingerie and bedecked in jewels.

RS There is a general perception that you have fo-cused on nudes in your work, but in reality you have painted very few. Why do you think your work has been so identified with this subject?

JC At the beginning, there was no sexual element in my work, or at least there was no evidence of me thinking about sexual things. When I first started painting middle-aged women, I would try to avoid anything sexual, not even showing a breast under the clothes. Early on I worked with pinups and that sort of thing, which I thought sometimes worked but mostly didn't. It was hard for me to get the reference out of my head. I do think that people responded very positively to the nudes that look like Lucas Cranach figures be-cause, for the first time, I didn't feel I had to have an "idea." I think this opened my work up to a much more direct way of thinking, in spite of or maybe because of a more methodical technique.

I dislike the idea that an image of a nude woman may stand for a certain idea of sin or temptation or perversity, or the opposite, of overcoming your inhibitions. It's a kind of cliché of freedom. On the other hand, it is a tremen-dous pleasure to paint women. Now, I'm hesitant to make nudes because it's so common for a man to paint them. But I love the image so much that

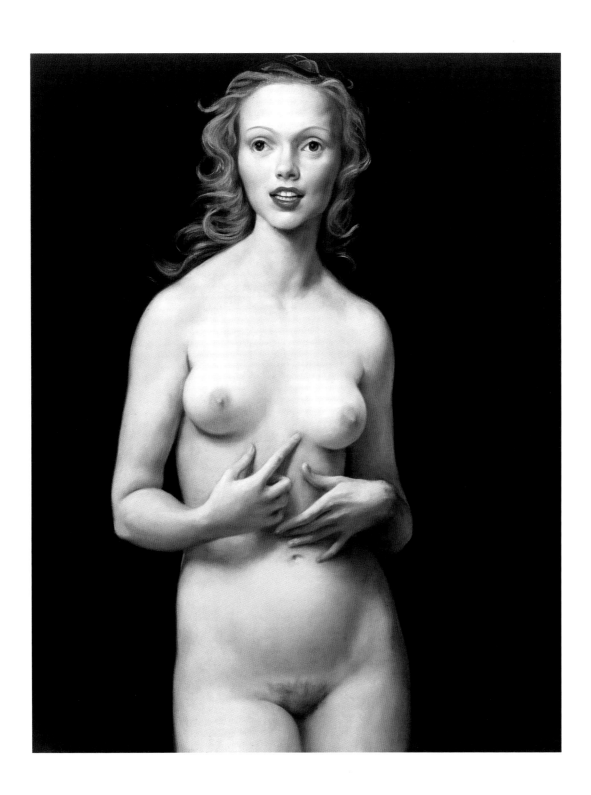

Honeymoon Nude, 1998

it is still a guilty pleasure. And when I see other men doing nudes, they have to be really good. Otherwise, I just feel like, what is this supposed to stand for? If it's not even as good as photographic porno, why paint it at all?

RS How does *Nude on a Table* (2001, p. 107) fit into your thoughts about painting nudes? It's very different from your early pinups, like *Nude* (1994, p. 57) or even *Honeymoon Nude* (1998, p. 79).

JC It's just more academic. *Nude on a Table* grew out of hiring a model for the first time in my life and not knowing what to do with her. It was really great that I could, in an un-creepy way, hire a naked girl who I was supposed to look at. The cliché of an artist usually involves young girls getting naked and the whole bohemian life, and I realized that I would like to try that and have that pleasure. But at the same time I felt uncomfortable with it. I had to figure out a way to paint her so that I didn't feel like a creep and it didn't feel depressing. It seemed to have little sexual content, actually. That's partly why I pushed that painting toward the academic with such a confident perspective.

I like the idea that Picasso looked at women all the time, but had a strange, antagonistic, questionable relationship to them. It's a strange act of adoration, but it's also very violent. My favorites are the pictures of Dora Maar, where she's crying, a weeping woman, and her eyes are like spoons with soup falling out of them. She's crying all the time, she's upset, and he's an asshole and has no sympathy. His coldness is fascinating and it's the real subject of the painting. I don't have the same temperament, but I like the idea of painting someone who is crying, of observing them like that. Have you ever experienced a moment when you can't believe how cold-hearted you are? It's an emotional moment. I've realized that it's analagous to painting — to paint

you have to be very observant and cold about it. This act of portraying is, in a way, paradoxical. I have to have a feeling to paint, but as a painter I cannot have the feeling so much that I can't objectify the image.

RS What's the difference for you in terms of working with various types of sources — life models, photographs, and art historical references?

JC I have been in a quandary for the last couple years. I am very conflicted about photography. I feel insecure about it. I hate the way photographs look, and I try to deny photographic space in my work and get away from photographic representation. At the same time, photography — especially pornography — is a much more vivid and vicarious experience than any painting could ever be. I'd always gotten a depressing feeling when looking at a painting of a nude woman, and thought, "Well, am I supposed to get excited by this? Because I'm not." So it's kind of about paintings of nudes failing to be as good as photographs.

My New York show in 2001 was about not wanting to use pop sources, images that are not mine. I've kind of weaned myself from that technique and that routine, partly because I see it in so many other people's work that I'm just tired of it. That was mainly why I started using live models. I didn't want to have that constant anxiety of needing to have a source, although that introduced this strange academic world to my work. I didn't want to feel I was cheating by using photographs.

For me the photographs are a starting point; they provide scenarios more than information. I like the faces of photographs because they're not anybody I know, which makes it very easy for me to project what I want the figures to look like right on top. I make them into me or into Rachel. I change the expression, change the nose. When working from life, it's very difficult to stray from

appearances. With the authority of the person right there, they're so much more interesting than your ideas could ever be.

RS Do you see a difference in your paintings when you work from photographs? Does your process involve the piecing together of photographic imagery rather than a direct representation when you have a model?

JC Well, actually, when there is a model I tend to piece things together. With a photograph, it's more the scenario I'm interested in. For example, *Stamford After-Brunch* (2000, pp. 2–3) was inspired by an advertisement. It was a stock image of a group of women getting together when the men are gone. The women really hash it out together and they drink gourmet coffee, holding the cup with both hands, or they drink martinis. I couldn't make that up. Last summer, when visiting Athens, I realized that the Renaissance painters didn't make up all of their scenes. The idea of the Madonna looking adoringly down at her baby is not something they invented. The Greeks made pictures like this of women and the poses are all the same. They showed how to make things realistic and still be expressive.

RS Are there certain sources that you find more interesting? You have talked about advertising and even pornography from the 1970s.

JC I like to look at women's magazines like *Cosmo* a lot. I look at them to find images that I like, but I end up reading them — the interviews with now-dead celebrities, everything from losing weight to why it's okay to sleep with your boss. *Cosmo* always has these very weird takes on things. At least it used to in the 1970s. I got kind of interested in that whole mindset. Magazines give me the feeling that women must be like small animals in the forest, living with tremendous anxiety and fear. You know, the way you

feel when you see a squirrel — you look at the squirrel and think, "He's so nervous. The hawks circling above, the fox down below." It must be nerve-wracking. Sometimes I actually get the same feeling looking at *Playboy* as I do from reading women's magazines. I used to think, "God, it's such hell being a man." I guess that's a dark view, but it seems like we live in a society with a lot of anxiety.

You realize how much people's lives are lived with fears, with societal fears. To me, that's what *Stamford After-Brunch* is about. I thought of an image that would strike terror without being violent, a terrifying image in a way. It's an acerbic, cynical take on culture, but it also shows how much of life is lived not through one's own eyes. That's what I find compelling about using imagery from the advertising industry.

RS Many of the anxieties you are referring to seem particularly American. Do you find yourself drawn to American imagery?

JC The reason I wanted one of the women in *Stamford After-Brunch* to be dressed up in a sort of swami outfit is I just wanted some relief from Americana. I wanted it to be kind of exotic. Strangely enough, the most American-looking images I find come from European stock photo books. *Homemade Pasta* (1999, p. 92) was inspired by European images of a man and woman making homemade pasta.

RS So the original image had a man and a woman rather than two men?

JC Yeah. The reason I use stock photos is because they seem extremely sinister. I'm certainly not the first person to notice that ads are demonic. I find them fearsome. I hate images like this so deeply, but find them uncomfortably close to real life. When it's such an ugly image, I find it's exhilarating that I'm able to make it a luscious painting.

Installation view at Galerie
Jennifer Flay, Paris, 1994

RS Do you feel old-fashioned?

JC Well, in a funny way, I feel weirdly brand-new, because it is so anachronistic to paint. Right now I'm reading *The Quiet American* by Graham Greene. And you can't help but feel that being an American is like having deep principles, but not being aware of them, and everything you do consciously is stupid, clownlike. I think I have great skills and great sensitivity to paint, and I think I understand European painting, but sometimes I feel like my American-ness is a handicap or a clown outfit that I constantly find myself in. There's nothing I can do about it.

RS You tend to think about your work in your gallery exhibitions in terms of groupings. For example, the geeky guys like *The Berliner* (p. 56) and the pinup nudes appeared together in 1994. Not very many painters talk about their work in terms of its installation, but this seems important to you.

JC For my show in New York in 2001 I hung my academic drawings with the paintings. I think I'm the only one who liked that idea. I got into the persona of a Midwestern art professor, a hotshot realist guy. I liked the way it made the whole thing look like this really strange out-of-place show, at least in the context of New York City.

Being in New York in the late 80s and 90s I used to think much more about certain contexts, styles, and how my paintings fit into contemporary art. I used to think much more in terms of how my work would be interpreted and tried to make things that would be difficult to interpret in the context of contemporary art. In other words, I tried to make difficult art that would be difficult for the people who thought they had a leg up on painting.

When I started out, I really thought a show needed to have a cohesive style. I would try to imagine a persona that I would be. That started

breaking apart during the show of big breast paintings because I had also made *Heartless* (1997, p. 72) and *The Cripple*. In earlier shows, I mixed the paintings with drawings, in a staccato way of hanging. But lately I have not felt the need to embody an idea and a kind of set-up, rhetorical argument. In my last show, I felt that every painting was individual, so that's the way I hung it. I just wanted it to look domestic.

Strangely, my paintings are getting more uniform in their style as time goes on. I think I've gotten a lot better. I don't think that my old paintings compare with my new paintings physically. I like my early ideas; they are clever, their spirit is clever, and some of them are quite beautiful. But they're very sparse when I consider them in light of my recent work.

I was fighting the art society much more early on, and up until about five or six years ago, I really felt antagonistic toward it. But it's silly for me to feel antagonistic now. I've been rewarded richly in the last five years, so the idea that I'm not accepted or I'm an outsider is ridiculous. It's more my own insecurities that I confront now. It's a big source of insecurity to me that, basically, I'm conservative. Maybe I'm just an academic realist. You have to deal with your own complacency and your own insecurity. It's always much easier to have enemies.

RS So would you say your work started out as reactionary?

JC Yes, that was on purpose. I was playing into the context of the early 90s, when it was very easy to exploit people's inhibitions about painting, people who felt a responsibility to respond positively to different forms of installation and performance. And it was easy to parody the will to be progressive.

RS Did you get the reaction you wanted? Many people have called you sexist.

JC Yes, there were accusations that I was sexist because of the big breast paintings, but it actually started before that, with the older women, because I was showing them in an unflattering light. But the funny thing is that just representing them was considered exploitative. Strangely enough, if you don't show women in a flattering sexualized manner, it's seen as sexist. And if you do, that's sexist too. That was the wonderfully, delightfully ironic point. It's like when you're playing Scrabble, and you suddenly notice you could put the *X* on a triple going both directions, and nobody has seen it. I had the *X*. And that's the way those paintings occurred to me. There was an opportunity to make provocative paintings that don't look like provocative paintings. I took that opportunity although I eventually got tired of working that way.

I think I was also kind of depressed then, and I was a bit masochistic in the way I painted — not giving myself any pretty colors to work with, using black a lot. Let's face it: the reason people said I was so misogynistic is because they despised those figures. I think I was the only one who loved them, actually, and everybody else thought that because they hated them, it was my fault. But I was moved by these divorced women.

RS And what about your images of men? Were the lonely guys and the gay couples also meant to provoke?

JC Well, sure, yeah. I guess it's a provocation to paint an image of gay men in my style. You know, I first made those paintings in the context of my female nudes. With *Homemade Pasta* I just wanted an image of totally unsexualized domestic life. And then I kept thinking that this image of a gay couple is also political. It's interesting to me that people feel automatically guilty, kind of uncomfortable, when looking at that painting. An image of two men has a strange authority, an ability to make liberal people cringe and get nervous about what they're going to say. This is the same way that images of black people make people nervous.

My gay couple is, in a way, an intimidating image. There's this idea that by looking at them, we are trying to take away their right to happiness. At least that's the way I felt about *Two Guys* (2002, p. 111). The top guy's expression has a tinge of resentment in it, like "Don't take this away from me. How dare you even consider trying to take this happiness away from me?" He's protesting a bit too much, but he's not ashamed. I thought it was a good image of shame and of pride — of them shaming you for how you might feel about them.

RS Are you suggesting that we are not so comfortable with the images that are associated with political correctness?

JC It's a PC icon — the happy, proud gay couple. On the other hand, by creating it, it's a way of showing affection to the image. That's another reason I don't like to paint nudes all the time. It's just too easy an equation of loving the canvas, fantasizing your touch, caressing and touching a naked lady, that kind of thing. So painting *Homemade Pasta* was just a way of having some resistance, and also making an image that's intimidating, in the same way that an image of a naked lady is intimidating.

RS So you're confronting viewers.

JC Yeah, obviously I'm trying to make them uncomfortable. Objectifying subjects has always been an issue for me in figurative art. There's a question of whether you have a right to represent someone, particularly in light of all the bullshit from the 90s — women taking cameras and representing themselves, black people representing

themselves. I always thought it was a silly idea that you have to have a kind of right to represent what you're going to represent. On the other hand, the residual guilt is strong enough that I did have qualms making this work. I'm always very conscious of whether I have the right to represent something, and I've always wondered how I can cast off that inhibition.

RS Do you still feel antagonistic toward the viewer today? Do you think your work continues to cause the strong reactions it did in the beginning?

JC Now, it's not as tempting to try to take the piss out of people by making a reactionary painting or working in a reactionary style. It has become harder to pretend to be a political artist. I think, in a funny way, I adopted the idea that I should always be political because of the atmosphere. I realize more and more that for me, it's about the style. I'm not as in control as I thought I was, let me put it that way. What has guided me has always been the physical yearning to paint a certain way. It makes me feel good to use a certain color, for example. All my good paintings have been because I've followed my physical urges in making the painting.

I've been thinking that I need to accept how conservative I am in every way, but the hardest thing for me to swallow is to be aesthetically conservative. Basically, I enjoy normality in art. I like boring things, or I like pretty things. It's true that some people think my paintings are bombastic and nutty, but in another way, they're the closest to everybody's idea of what an oil painting is. Their mystery lies, I hope, in how conventional they are.

RS There is something unknowable in your work. Even after looking at it for a long time you just can't wrap it up easily and say, "this is what it's about."

JC That may be because there's a lot of nostalgia in my work. I hate to admit that, but I think it's true.

RS Nostalgia for something particular?

JC For old painting. Nostalgia for childhood. I long for California where I grew up. I long for breaking waves. They just kill me whenever I see them. That's another painting I want to make.

I've never been crazy about the future. I'm just not a progressive person, and I guess as an artist you're supposed to be. It's one of the admired virtues of modernism to be forward-looking and progressive.

RS Do you think you were trying to paint those types of landscapes with *Girl on a Hill* (1995, p. 62) and *SuperAngel* (1995, p. 63)?

JC Yeah. I was trying to get out of a sense of isolation and remember thinking, when I close my eyes, what do I think of and what do I see? Hilltops in California. I haven't been back there in a long time, but when I see the yellow grassy hills of Northern California and the way that the clouds go behind them, it makes me cry. I wanted to make that place. The girls were only there because you've got to have something in the center. The hard part is always the place, meaning either the setting or the anti-place if the background is monochromatic. For example, in *Fishermen* (2002, p. 112), the gaudy space of the seagulls and ocean and all that crap is not something I've figured out. Part of the reason I want to paint directly now instead of in stages with an underpainting is to make the whole painting happen at once, rather than creating a fetishized object in a void, which is what underpainting lends itself to.

RS *Fishermen* feels like a very solid genre painting. Where does its inspiration come from?

JC It was in a dream. I had a dream that I was look- ing at that painting. There was a fisherman on a boat and a rope held in a loop. And in the dream, the back part of the painting was done like a clas- sical illustration, like a robust nineteenth-century Winslow Homer image. The rope was really re- alistic and strangely high-focused. There weren't two guys in the dream — only one sailor — but I loved the idea of this noose mirroring the space between two bodies.

RS Do you often see images for paintings in your dreams?

JC I dream of the painting, not the image. In the dream I am actually looking at the painting. I don't know about the meaning of the painting at all; what might be called its symbolism is myste- rious to me, as well.

RS Could you imagine making paintings without figures?

JC Not really. Sometimes I think that if I were to die tomorrow, what would I regret? I would regret not painting larger paintings, and I think I would regret not getting really good at landscape be- cause I think that being able to represent the world — the sky and sunlight — is one of the most lovely powers you can have. I can't believe I haven't explored it more.

This interview took place in New York on January 10, 2003.

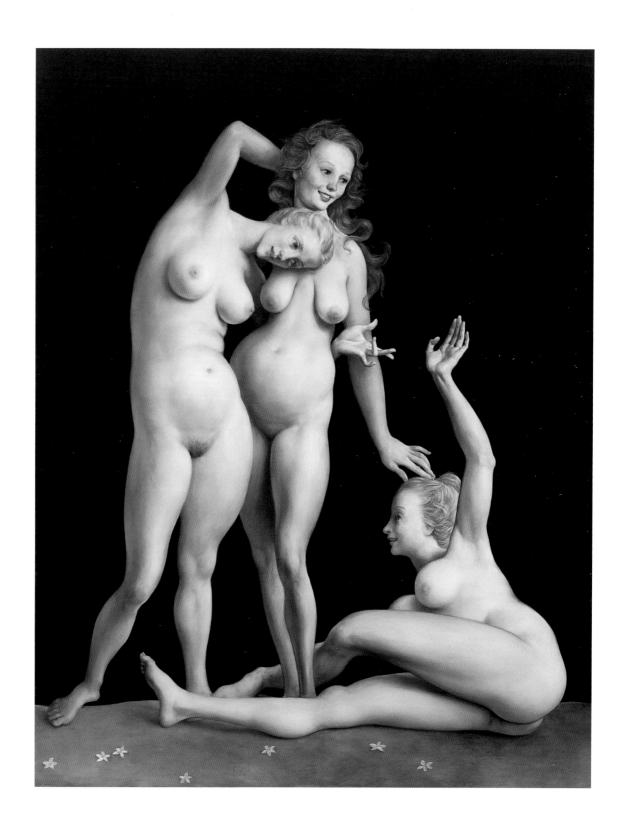

Three Friends, 1998

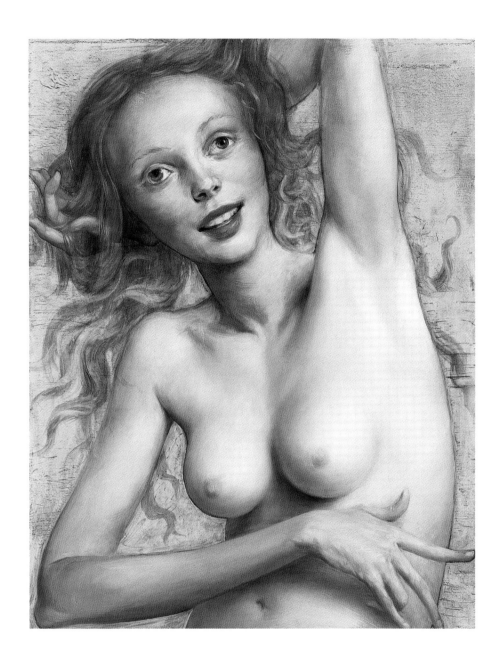

Gold Nude, 1999

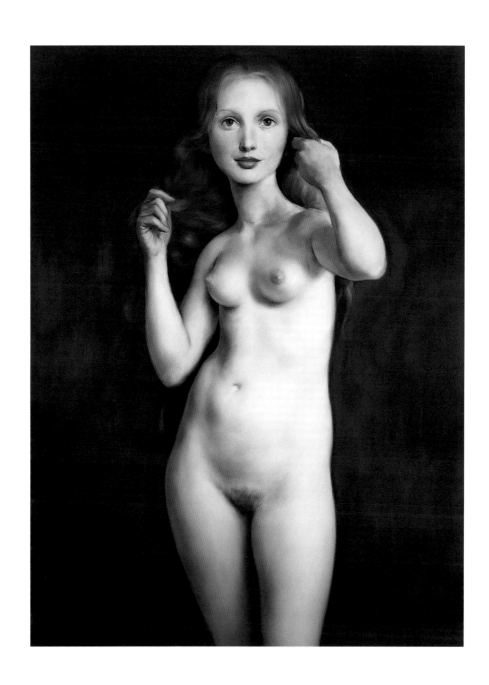

Nude with Raised Arms, 1998

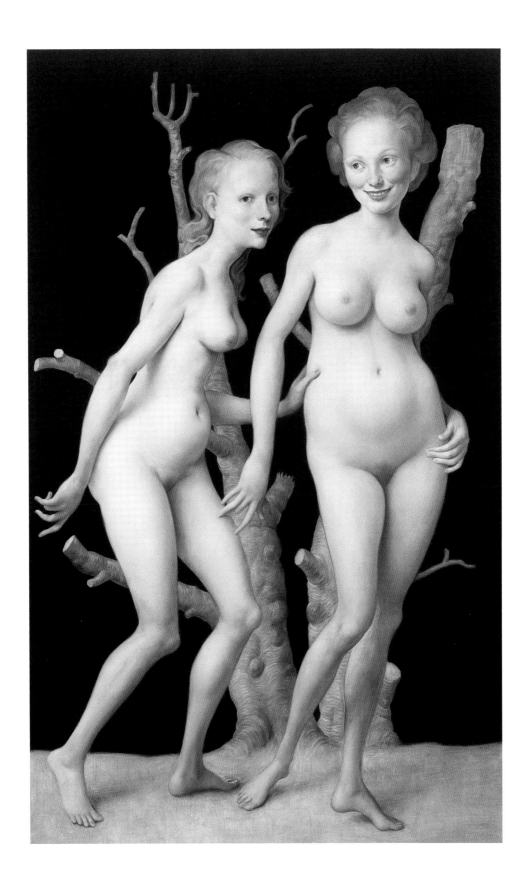

The Pink Tree, 1999

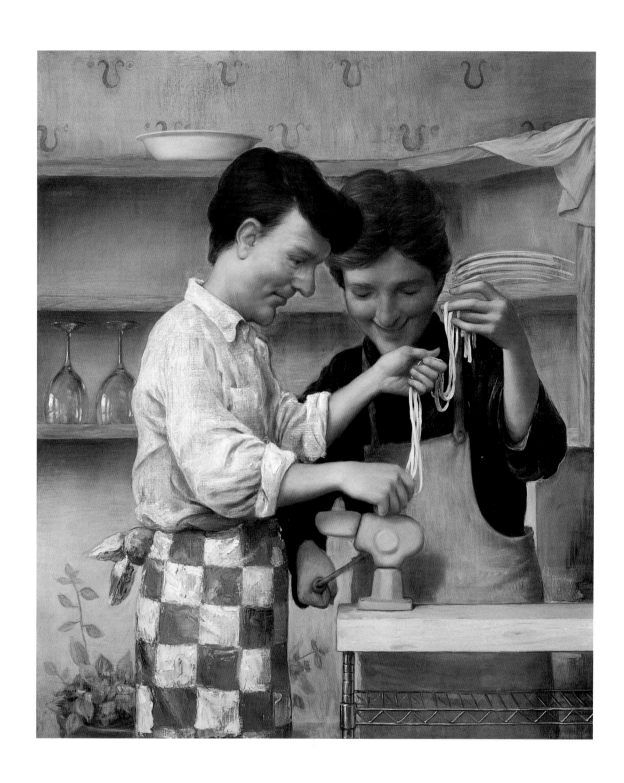

Homemade Pasta, 1999

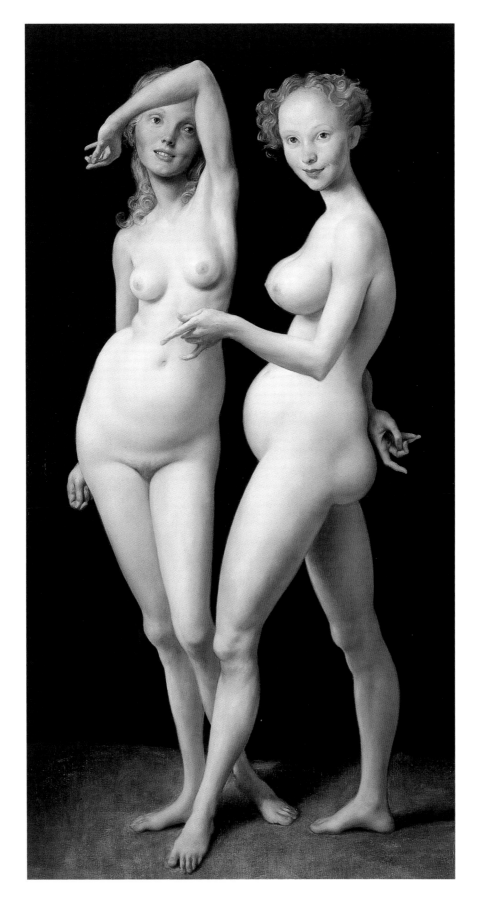

The Old Fence, 1999

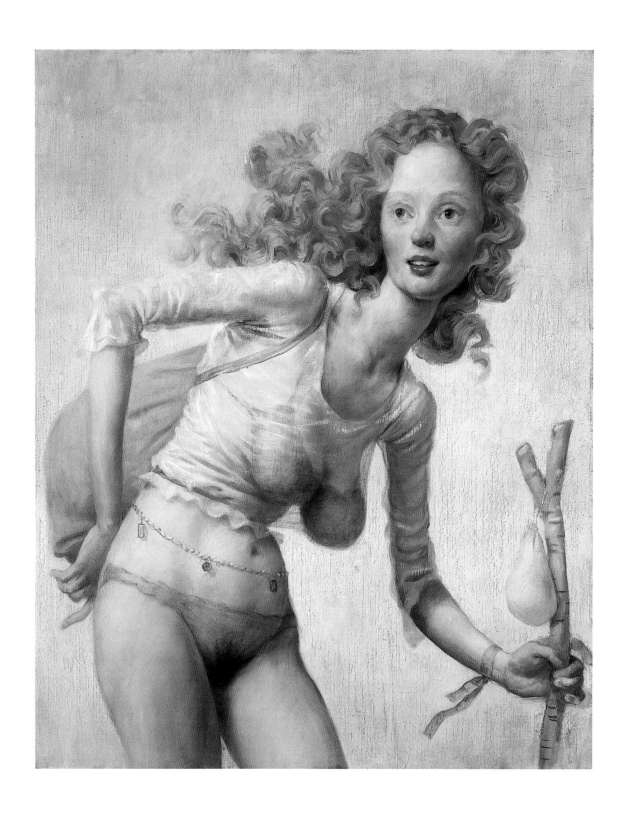

Hobo, 1999

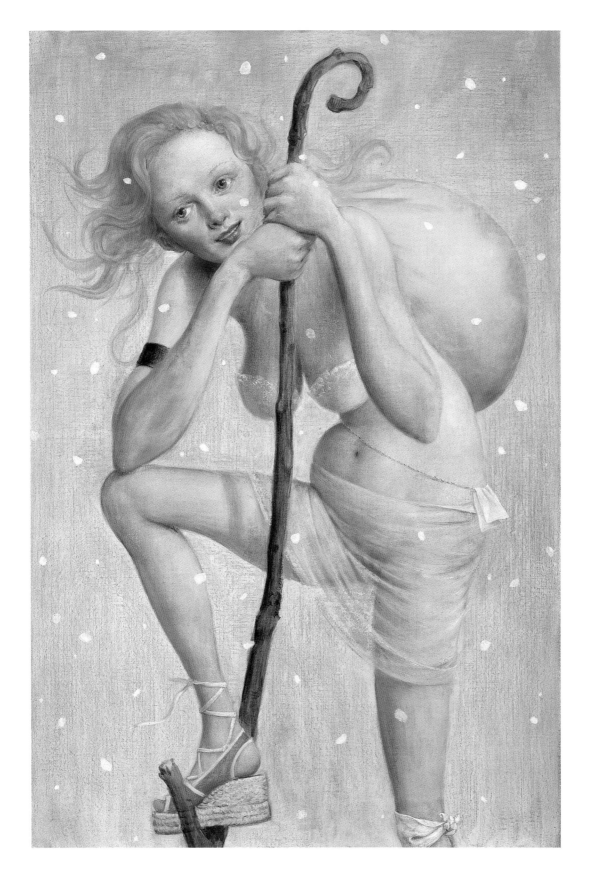

Sno-bo, 1999

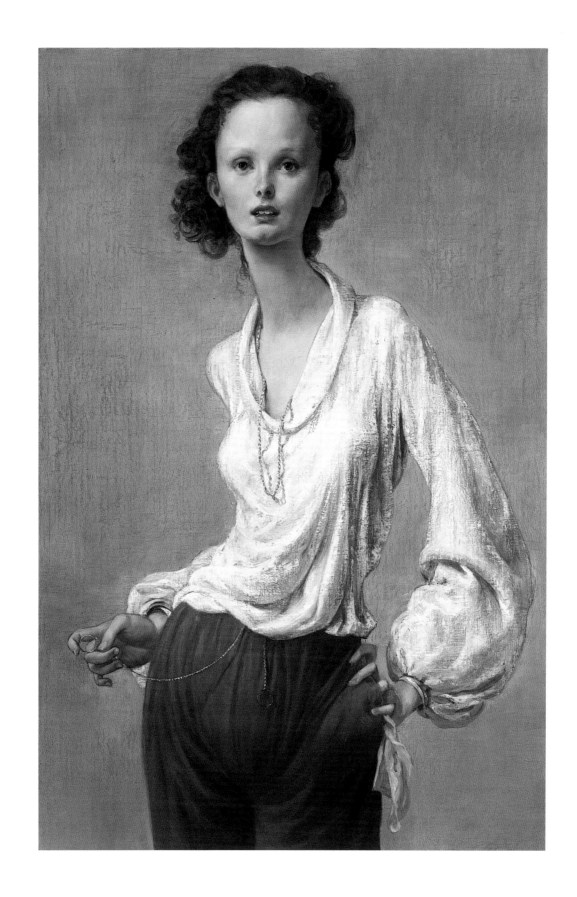

Gold Chains and Dirty Rags, 2000

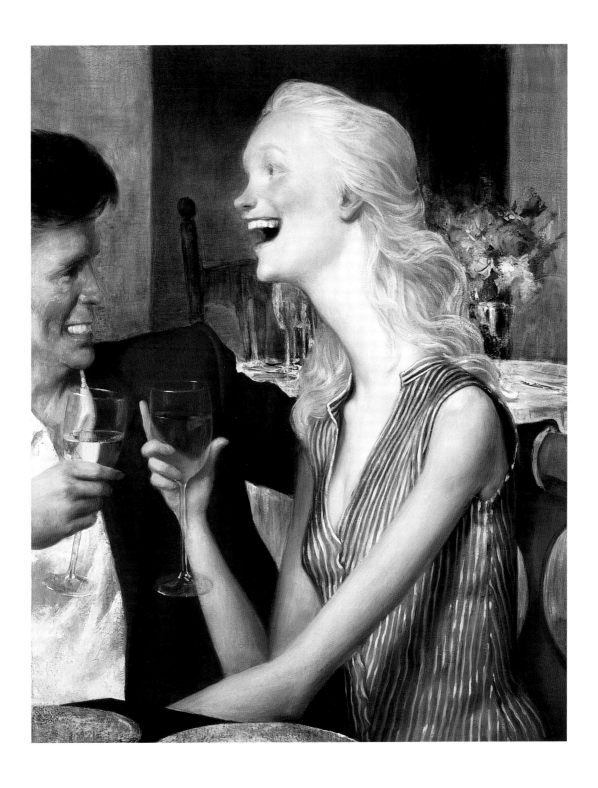

Park City Grill, 2000

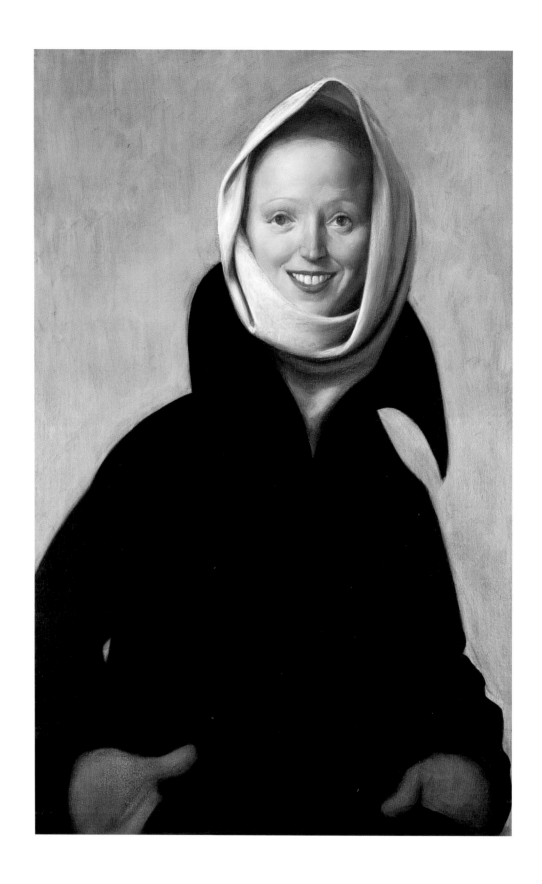

The Cuddler, 2000

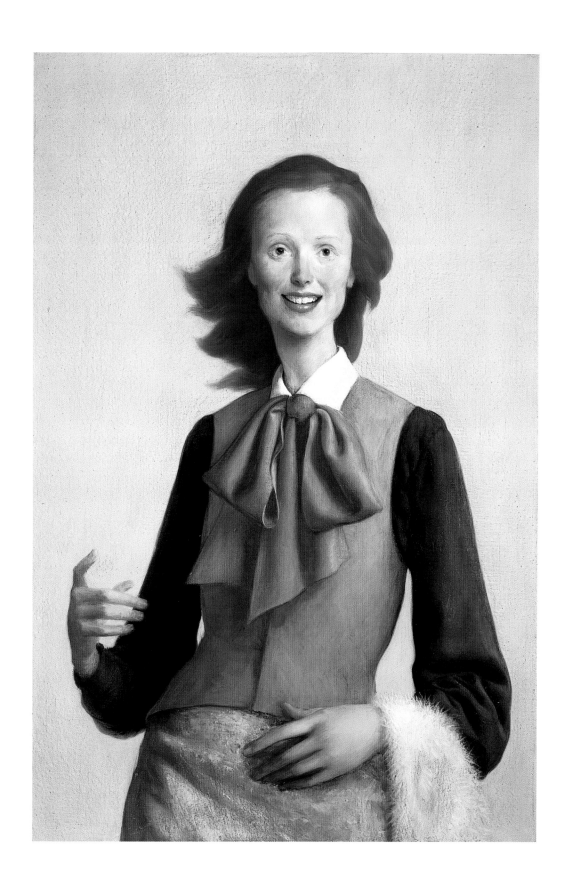

The Big Bow, 2000

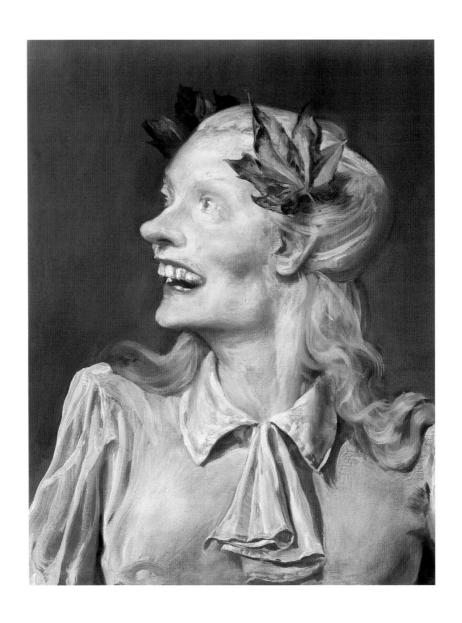

Minerva, 2000

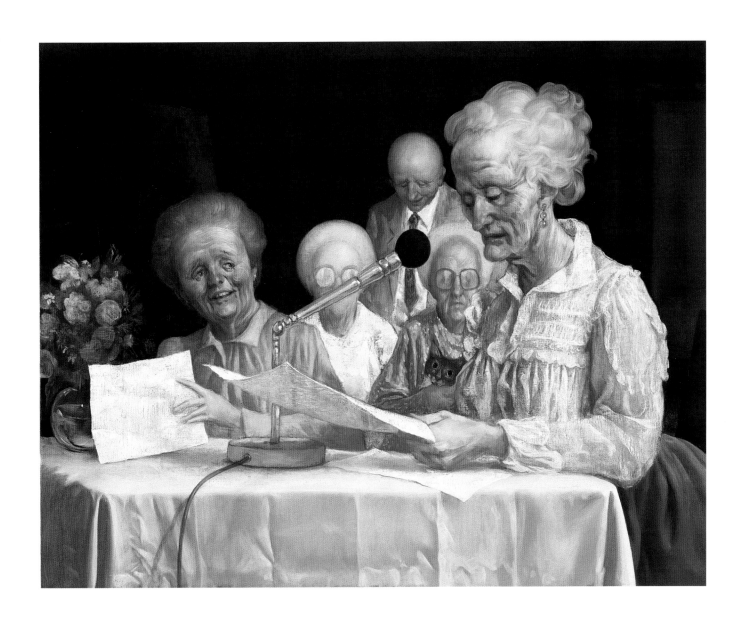

The Activists, 2000

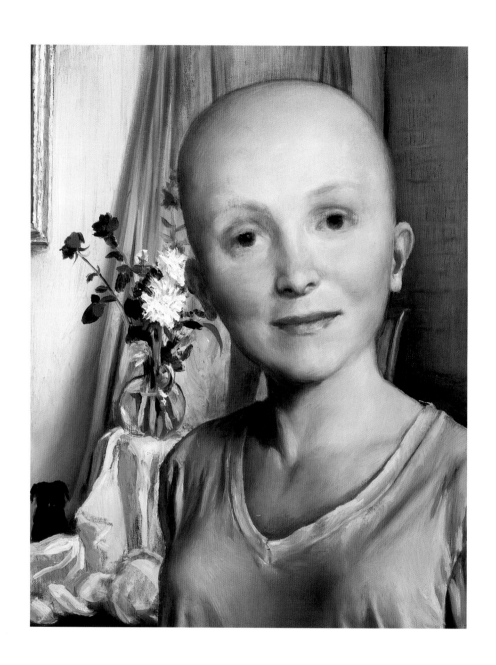

Portrait of Chewy, 2001

The Moroccan, 2001

OVERLEAF
The Gardeners, 2001

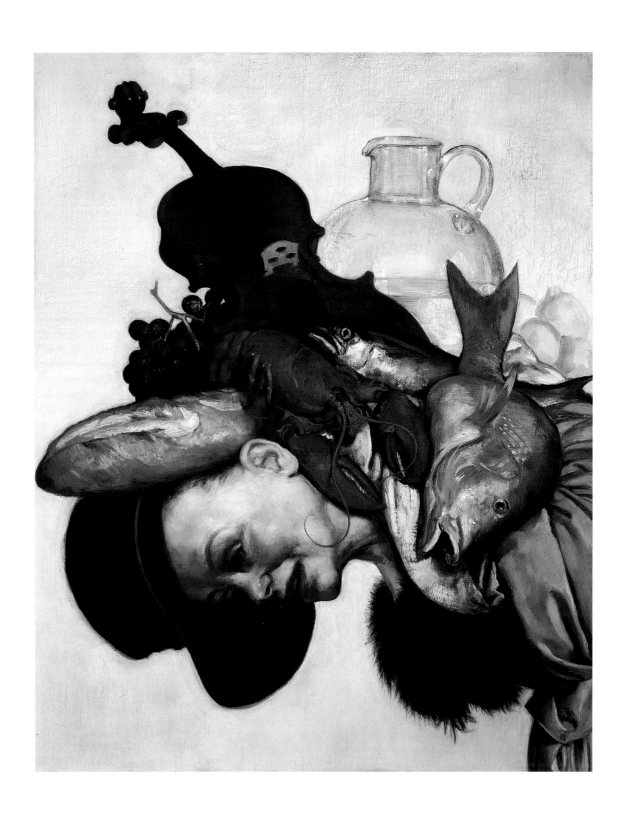

The Lobster, 2001

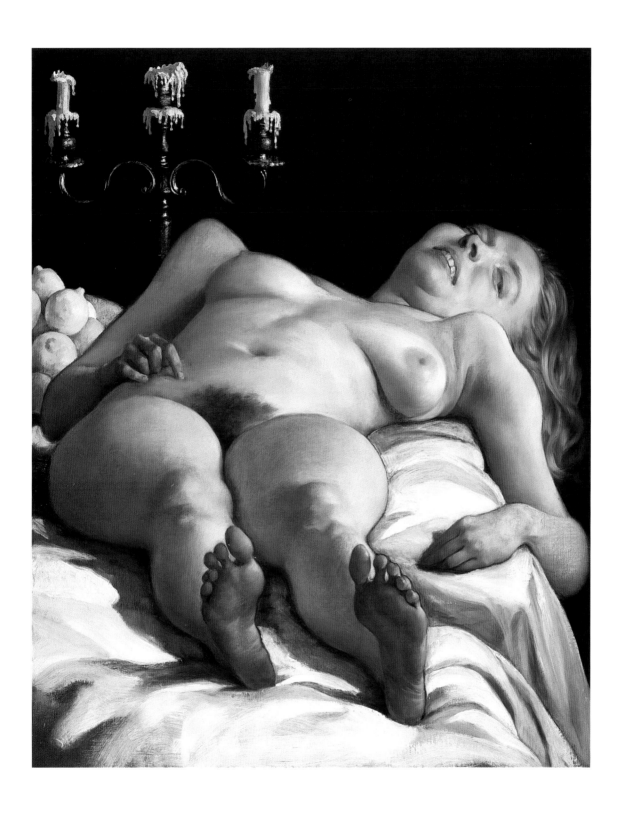

Nude on a Table, 2001

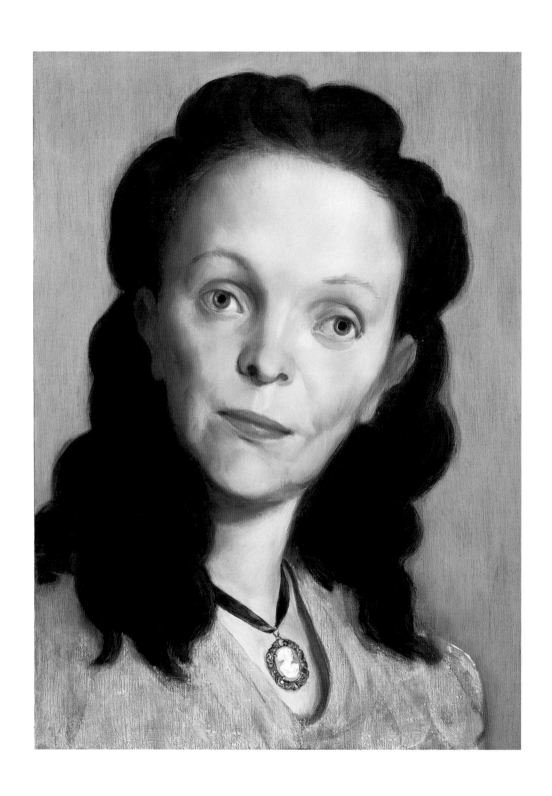

Angela, 2001

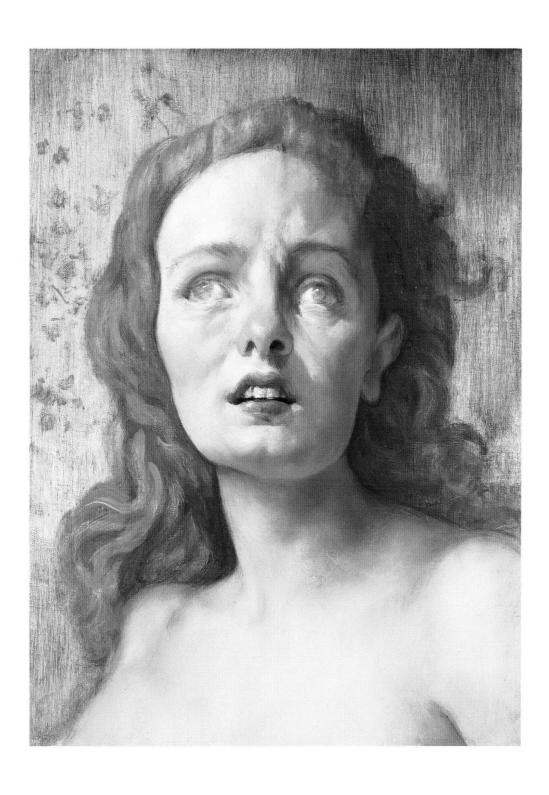

The Clairvoyant, 2001

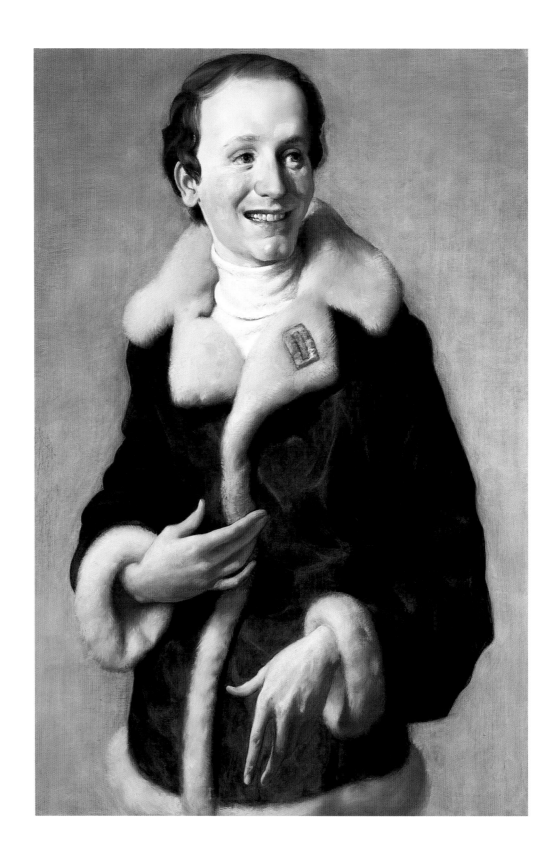

The Producer, 2002

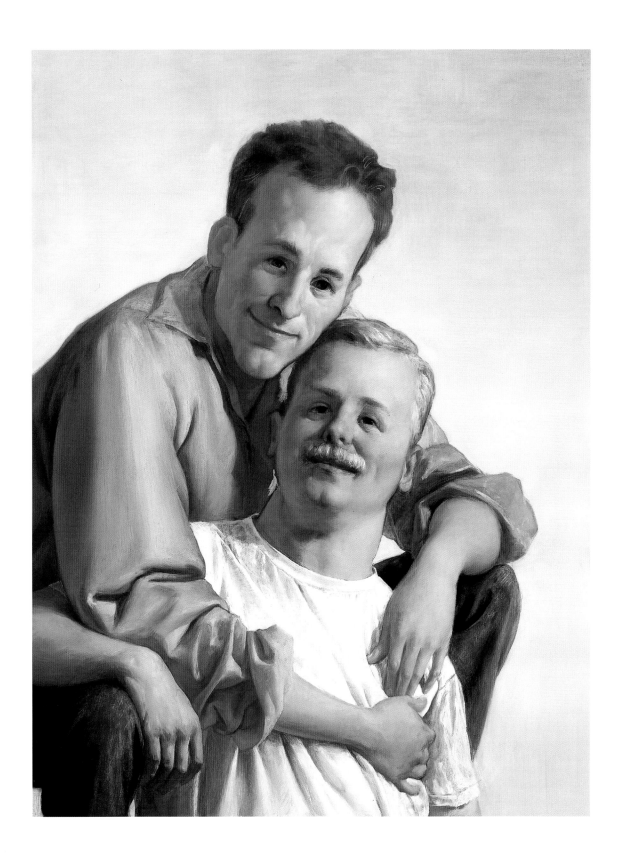

Two Guys, 2002

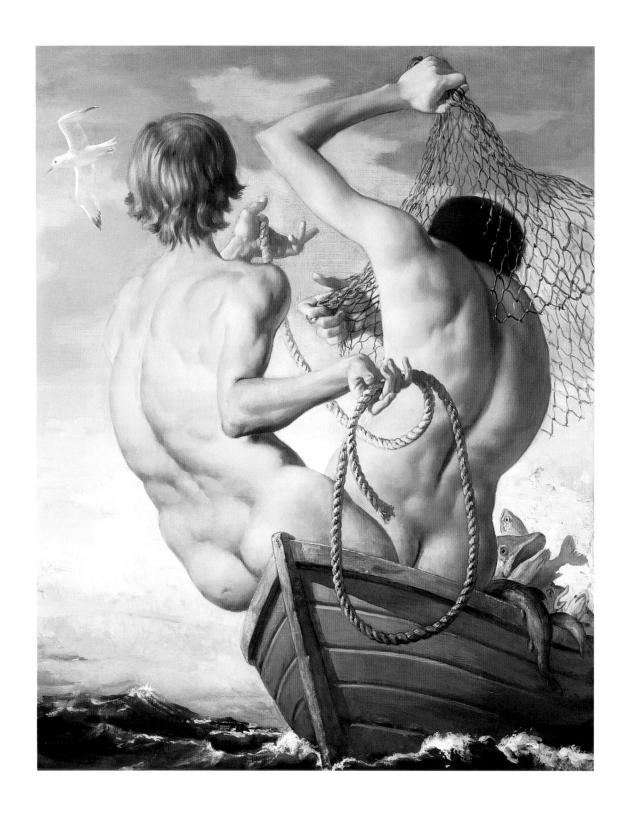

Fishermen, 2002

List of Plates

Homemade Pasta *
1999
Oil on canvas
50 x 42 in. (127 x 106.7 cm)
The Rachofsky Collection,
Dallas
p. 92

The Old Fence *
1999
Oil on canvas
76 x 40 in. (193 x 101.6 cm)
Carnegie Museum of Art,
Pittsburgh; A. W. Mellon
Acquisition Endowment Fund
2000.4.1
p. 93

The Pink Tree *
1999
Oil on canvas
78 x 48 in. (198.1 x 121.9 cm)
Hirshhorn Museum and
Sculpture Garden,
Smithsonian Institution,
Joseph H. Hirshhorn
Purchase Fund, 2000
p. 91

Sno-bo *
1999
Oil on canvas
48 x 32 in. (121.9 x 81.3 cm)
Private collection
p. 95

The Activists
2000
Oil on canvas
38 x 48 in. (96.5 x 121.9 cm)
Collection of Adam D.
Sender, New York
p. 101

The Big Bow *
2000
Oil on canvas
36 x 24 in. (91.4 x 61 cm)
Edwin C. Cohen Collection
p. 99

The Cuddler *
2000
Oil on canvas
38 x 24 in. (96.5 x 61 cm)
Collection of Frances and
John Bowes, San Francisco
p. 98

Gold Chains and Dirty Rags
2000
Oil on canvas
48 x 32 in. (121.9 x 81.3 cm)
Private collection
p. 96

Minerva
2000
Oil on canvas
28 x 22 in. (71.1 x 55.9 cm)
Collection David Teiger
p. 100

Park City Grill *
2000
Oil on canvas
38 1/16 x 30 in. (96.7 x 76.2 cm)
Collection Walker Art
Center, Minneapolis
Justin Smith Purchase Fund,
2000
p. 97

Stamford After-Brunch *
2000
Oil on canvas
40 x 60 in. (101.6 x 152.4 cm)
Collection of Andrea Rosen
pp. 2–3

Angela
2001
Oil on canvas
22 x 16 in. (55.9 x 40.6 cm)
Collection of Ninah
and Michael Lynne
p. 108

The Clairvoyant *
2001
Oil on canvas
22 x 16 in. (55.9 x 40.6 cm)
Collection of Mark Fletcher
and Tobias Meyer, New York
p. 109

The Gardeners *
2001
Oil on canvas
52 x 75 in. (132.1 x 190.5 cm)
Collection David Teiger
pp. 104–5

The Lobster *
2001
Oil on canvas
40 x 32 in. (101.6 x 81.3 cm)
Collection of Dianne
Wallace, New York
p. 106

The Moroccan
2001
Oil on canvas
26 x 22 in. (66 x 55.9 cm)
Purchase 2002, Musée
National d'Art Moderne,
Centre Pompidou, Paris
p. 103

Nude on a Table *
2001
Oil on canvas
40 x 32 in. (101.6 x 81.3 cm)
The Art Institute of Chicago,
Modern and Contemporary
Discretionary and Maurice
Fulton Funds; through prior
acquisitions of the William H.
Bartels Award Fund,
Mrs. Charles S. Dewey,
Mr. and Mrs. Frank G. Logan,
and Florene May Schoenborn
p. 107

Portrait of Chewy
2001
Oil on canvas
18 x 14 in. (45.7 x 35.6 cm)
Private collection
p. 102

Fishermen *
2002
Oil on canvas
50 x 41 in. (127 x 104.1 cm)
Collection of Adam D.
Sender, New York
p. 112

The Producer *
2002
Oil on canvas
48 x 32 in. (121.9 x 81.3 cm)
Collection of Beth Swofford,
Los Angeles
p. 110

Rachel in Fur *
2002
Oil on canvas
20 x 16 in. (50.8 x 40.6 cm)
Private collection
p. 76

Two Guys *
2002
Oil on canvas
48 x 36 in. (121.9 x 91.4 cm)
Collection of
Alan Hergott and
Curt Shepard,
Beverly Hills
p. 111

* This symbol indicates works
included in the exhibition.

Biography and Exhibition History

Born 1962, Boulder, Colo.

B.F.A., Carnegie Mellon University, Pittsburgh, Pa., 1984

M.F.A., Yale University, New Haven, Conn., 1986

Lives and works in New York

Solo Exhibitions

2003

John Currin: Works on Paper, Des Moines Art Center, Des Moines, Iowa; traveled to Aspen Art Museum, Aspen, Colo.

Sadie Coles HQ, London

2002

Regen Projects, Los Angeles

2001

Andrea Rosen Gallery, New York

2000

Monika Spruth Galerie, Cologne, Germany

Sadie Coles HQ, London

1999

Andrea Rosen Gallery, New York

Regen Projects, Los Angeles

1997

Andrea Rosen Gallery, New York

Sadie Coles HQ, London

1996

Regen Projects, Los Angeles

1995

Andrea Rosen Gallery, New York

Donald Young Gallery, Seattle

Fonds Régional d'Art Contemporain Limousin, Limoges, France; traveled to Institute of Contemporary Arts, London (exh. cat.)

Jack Hanley Gallery, San Francisco

1994

Andrea Rosen Gallery, New York

Galerie Jennifer Flay, Paris

1993

Critical Distance, Ado Gallery, Antwerp, Belgium (exh. cat.)

Monika Spruth Galerie, Cologne, Germany

1992

Andrea Rosen Gallery, New York

1989

White Columns, New York

Selected Group Exhibitions

2002

American Standard: (Para)-Normality and Everyday Life, Barbara Gladstone Gallery, New York (exh. cat.)

Dear Painter, paint me ..., *Painting the Figure since late Picabia*, Musée National d'Art Moderne, Centre Pompidou, Paris; Kunsthalle Wien, Vienna; and Schirn Kunsthalle, Frankfurt (exh. cat.)

Drawing Now: Eight Propositions, The Museum of Modern Art, Queens, N.Y. (exh. cat.)

The Honeymooners, with Rachel Feinstein, The Hydra Workshop, Hydra, Greece (exh. cat.)

Naked Since 1950, C & M Arts, New York (exh. cat.)

2001

About Faces, C & M Arts, New York

Drawings, Regen Projects, Los Angeles

The Way I See It, Galerie Jennifer Flay, Paris

Works on Paper from Acconci to Zittel, Victoria Miro Gallery, London

2000

Couples, Cheim and Read, New York

Innuendo, Dee/Glasoe, New York

Kin, Kerlin Gallery, Dublin

Whitney Biennial, Whitney Museum of American Art, New York (exh. cat.)

00, Barbara Gladstone Gallery, New York

1999

Carnegie International 1999/2000, Carnegie Museum of Art, Pittsburgh, Pa. (exh. cat.)

Etcetera, Spacex, Exeter, England

Examining Pictures: Exhibiting Paintings, Whitechapel Art Gallery, London; Museum of Contemporary Art, Chicago; traveled to UCLA Hammer Museum, Los Angeles (exh. cat.)

I'm Not Here: Constructing Identity at the Turn of the Century, Susquehanna Art Museum, Harrisburg, Pa.

John Currin and Elizabeth Peyton, Carpenter Center for the Visual Arts, Harvard University, Cambridge, Mass.

Malerei, INIT-Kunsthalle, Berlin

The Nude in Contemporary Art, Aldrich Museum of Contemporary Art, Ridgefield, Conn. (exh. cat.)

Positioning, Center for Curatorial Studies, Bard College, Annandale-on-Hudson, N.Y.

Troublespot Painting, Museum van Hedendaagse Kunst Antwerpen (MUHKA), Antwerp, Belgium (exh. cat.)

1998

From Here to Eternity: Painting in 1998, Max Protetch Gallery, New York

Hungry Ghosts, Douglas Hyde Gallery, Dublin (exh. cat.)

More Fake, More Real, Yet Ever Closer, Castle Gallery, College of New Rochelle, New York (exh. cat.)

Now and Later, Yale University Art Gallery, New Haven, Conn.

Pop Surrealism, Aldrich Museum of Contemporary Art, Aldrich, Conn. (exh. cat.)

Portraits: People, Places and Things, Marianne Boesky Gallery, New York

Young Americans 2; Part Two, Saatchi Gallery, London (exh. cat.)

1997

American Art 3, Whitney Museum of American Art, New York (exh. cat.)

Feminine Image, Nassau County Museum of Art, Roslyn Harbor, N.Y.

Heart, Body, Mind, Soul: American Art in the 1990s, Selections from the Permanent Collection, Whitney Museum of American Art, New York

Painting Project, Basilico Fine Arts and Lehmann Maupin, New York (exh. cat.)

Projects #60: Currin, Peyton, Tuymans, The Museum of Modern Art, New York

The Tate Gallery Selects: American Realities. Views from Abroad. European Perspectives on American Art III, Whitney Museum of American Art, New York (exh. cat.)

1996

a/drift: Scenes from the Penetrable Culture, Bard College Center for Curatorial Studies, Annandale-on-Hudson, N.Y. (exh. cat.)

Answered Prayers, Contemporary Fine Arts, Berlin

Figure, Taka Ishii Gallery, Tokyo

Narcissism: Artists Reflect Themselves, California Center for the Arts Museum, Escondido, Calif. (exh. cat.)

Pittura, Castello di Rivara, Turin, Italy

Screen, Friedrich Petzel Gallery, New York

Sugar Mountain, White Columns, New York

Variations, op. 96: une selection d'oeuvres du Fonds Régional d'Art Contemporain, Poitou-Charentes, Musée de Cognac, Cognac, France

1995

B-Movie, Nicole Klagsbrun's Room, Phoenix Hotel, San Francisco

Collection, fin Xxe, Fonds Régional d'Art Contemporain Poitou-Charentes, Angoulême, France (exh. cat.)

Twenty-Five Americans: Painting in the 90s, Milwaukee Art Museum, Milwaukee, Wis. (exh. cat.)

Wild Walls, Stedelijk Museum, Amsterdam; traveled to the Institute of Contemporary Arts, London (exh. cat.)

1994

Don't Postpone Joy or Collecting Can Be Fun!, Neue Galerie, Graz, Austria; traveled to Austrian Cultural Institute, New York

Intercourse, Mustard, Brooklyn, N.Y.

Passing Through, Galerie Walcheturm, Zurich

A Series of Rotating Installations, with Andrea Zittel, Andrea Rosen Gallery, New York

Summer Group Show, Donald Young Gallery, Seattle

Up the Establishment, Sonnabend Gallery, New York

1993

Aperto 93, Venice Biennale, Italy (exh. cat.)

Just What Is It that Makes Today's Home So Different, So Appealing?, Galerie Jennifer Flay, Paris

Look at the Window, Museum Het Kruithuis, S'Hertogenbosch, Netherlands (exh. cat.)

Medium Messages, Wooster Gardens, New York

One of Us (Since You Stayed Here), Kunsthal Rotterdam, Netherlands

Project Unite Firminy, Unité D'Habitation Le Corbusier, Firminy, France (exh. cat.)

SOHO at Duke IV, Duke University Museum of Art, Durham, N.C.

1992

Dead Cat Bounce, Robbin Lockett Gallery, Chicago

Double Identity, Johnen and Schottle, Cologne, Germany

Figurative Work from the Permanent Collection, Whitney Museum of American Art, New York

1991

The Good, the Bad and the Ugly: Violence and Knowledge in Recent American Art, Ezra and Cecile Zilkha Gallery, Wesleyan University, Middletown, Conn.

Gulliver's Travels, Galerie Sophia Ungers, Cologne, Germany

Malerei, Johnen and Schottle, Cologne, Germany

Seven Women, Andrea Rosen Gallery, New York

1990

Andrea Rosen Gallery, New York

(not so) Simple Pleasures, MIT List Visual Arts Center, Cambridge, Mass. (exh. cat.)

Program Update White Columns, White Columns, New York (exh. cat.)

Total Metal, Simon Watson Gallery, New York (exh. cat.)

1989

Amerikarma, Hallwalls, Buffalo, N.Y.

Bibliography

2002

Berg, Sibylle. "Lots of Colorful Pictures, In Them." *Parkett*, no. 65, pp. 48–53.

Breuvart, Valerie, ed. *Vitamin P*. New York: Phaidon Press. Pp. 68–69.

Frankel, David. "John Currin." *Artforum* 40, no. 2 (March), p. 137.

Gingeras, Alison M., ed. *"Dear Painter, paint me . . . " Painting the Figure since Late Picabia*. Exh. cat. Paris: Musée National d'Art Moderne, Centre Pompidou; Vienna: Kunsthalle Wien; and Frankfurt: Schirn Kunsthalle.

————. "John Currin: The Backdoor Man." *Flash Art* 34, no. 226 (October), pp. 70–73.

Greene, David A. "Taking on the Masters." *Modern Painters* 15, no. 3 (autumn), pp. 66–67.

The Honeymooners. Exh. cat. Hydra, Greece: The Hydra Workshop.

John Currin. (book of drawings) Tokyo: Taka Ishii Gallery.

Seward, Keith. "Currin's Nudes." *Parkett*, no. 65, pp. 18–23.

Storr, Robert. "John Currin." *Artpress*, no. 280 (June), pp. 45–50.

Van de Wall, Mark. "Against Nature." *Parkett*, no. 65, pp. 30–35.

2001

Anderson, Maxwell, intro. *American Visionaries: Selections from the Whitney Museum of American Art*. New York: Harry N. Abrams.

Cotter, Holland. "The Gift of Art Ready to be opened." *New York Times*, December 21, pp. E41, E43.

Fineman, Mia. "Married to Each Other, to Art and to Art History." *New York Times*, October 28, p. 32, section 2.

Halle, Howard. "The Irony Chef." *Time Out New York* (November 29 – December 6), p. 86.

Naves, Mario. "John Currin's Place in History: Between Moreau and Eilshmius." *New York Observer*, November 26, p. 18.

Roberts, James. "A Question: Answers from . . . " *Frieze*, no. 63 (November/ December), pp. 65–80.

Schjeldahl, Peter. "At the Museums Straightforward Paint." *New Yorker* (December 17), p. 38.

Viveros-Faune, Christian. "John Currin at Andrea Rosen Gallery." *New York Press*, November 21–27, p. 26.

2000

Bonetti, David. "Trendy Currents at SFMOMA." *San Francisco Examiner*, July 7, p. C14.

Clifford, Katie. "John Currin." *ARTnews* 99, no. 1 (January), p. 164.

Higgie, Jennifer. "John Currin." *Frieze*, no. 54 (September–October), p. 115.

Kazanjian, Dodie. "Young Master." *Vogue* (November), pp. 480–85.

Kirby, David. "Beauty and the Bimbo." *ARTnews* 99, no. 5 (May), pp. 202–5.

Leffingwell, Edward. "John Currin." *Art in America* 88, no. 2 (February), pp. 124–25.

Licht, Matthew (aka "Reny Fleur"). "Art 'n' Shit: Painting Floppers for the Pleasure of It." *Juggs* (May), p. 35.

Rosenblum, Robert. "John Currin." *Bomb*, no. 71 (spring), pp. 72–78.

Sischy, Ingrid. "Gotta Paint!" *Vanity Fair*, no. 474 (February), pp. 140–47.

Whitney Biennial. Exh. cat. New York: Whitney Museum of American Art. Pp. 80–81.

1999

Arning, Bill. "John Currin." *Time Out New York* (December 2–9), p. 109.

Cappuccio, Elio. "Tutti Figli di Duchamp." *Tema Celeste*, no. 76 (October– December), pp. 48–53.

Goodrich, John. "John Currin." *Review* 5, no. 5 (November 15), p. 10.

Grosenick, Uta and Burkhard Riemschneider, ed. *Art Now. 137 Artists at the Rise of the New Millenium*. Cologne, Germany: Taschen. Pp. 100–4.

Kimmelman, Michael. "John Currin." *New York Times*, November 12, p. E42.

Knight, Christopher. "Young Artist Hobnobs with the Old Masters." *Los Angeles Times*, February 15, p. F16.

Paparoni, Demetrio. "Il non ritorno all'ordine" [John Currin, Richard Phillips, and Sean Landers with Demetrio Paparoni]. *Tema Celeste*, no. 76 (October–December), pp. 54–61.

Saltz, Jerry. "The Redemption of a Breast Man: Sanctify My Love." *Village Voice*, November 17–23, p. 77.

Sanders, Naomi. "John Currin at Regen Projects." *Art Issues*, no. 58 (summer), p. 50.

Schjeldahl, Peter. "The Elegant Scavenger." *New Yorker* (February 22 and March 1), pp. 174–76.

Schwabsky, Barry. "John Currin at Regen Projects." *Artforum* 37, no. 9 (May), pp. 182–83.

1998

Dorment, Richard. "A Brush with Young America." *Daily Telegraph*, August 26, p. 19.

Fox, Marisa. "High-Art/Low-Lifes." *World Art*, no. 19, pp. 72–73.

Kawachi, Taka. "John Currin." *Bijutsu Techo* (Tokyo) 50, no. 763 (November), pp. 28–33.

Kimmelman, Michael. "In Connecticut, Where Caravaggio First Landed." *New York Times*, July 17, p. E35.

Licht, Matthew [aka "Reny Fleur"]. "A Classy Show by One of America's Greatest Artists." *Juggs* (May), p. 43.

Negrotti, Rosanna. "States of Mind." *What's On*, October 7, pp. 8–9.

Smith, Alison. "Bras and Stripes." *Face*, no. 20 (September), p. 186.

Usborn, David. "Painted Ladies." *Independent Magazine* (London) September 12, pp. 24–25.

1997

Cotter, Holland. "Fervidly Drafting the Self and Sex." *New York Times*, October 10, p. 33.

Doran, Anne. "Projects 60: John Currin, Elizabeth Peyton, Luc Tuymans." *Time Out New York* (August 21–28), p. 39.

Halle, Howard. "Thanks for the Mammaries." *Time Out New York* (October 30–November 6), p. 41.

Marcoci, Roxana, Diana Murphy, and Eve Sinaiko, eds. *New Art*. New York: Harry N. Abrams, Inc. P. 40.

Schjeldahl, Peter. "The Daub Also Rises." *Village Voice*, July 29, p. 85.

Schwabsky, Barry. "Picturehood is Powerful." *Art in America* 85, no. 12 (December), pp. 80–85.

Smith, Roberta. "John Currin at Andrea Rosen Gallery." *New York Times*, November 7, p. E37.

———. "Realism Reconsidered from Three Angles." *New York Times*, August 1, p. C25.

Van der Walle, Mark. "Contract with a Coldhearted Muse." *Parkett*, no. 50/51, pp. 240–48.

Zizek, Slavoj. "The Lesbian Session." *Lacanian ink*, no. 12 (fall), pp. 58–69.

1996

Damianovic, Maia. "Le peinture au risque du dilemme [Painting on the Horns of a Dilemma]." *Artpress*, March, pp. 30–36.

Hall, James. "That's Why the Lady Has a Beard." *Guardian* (London), January 2, pp. 12–13.

Januszczak, Waldemar. "Goya of the Golden Girls." *Sunday Times* (London), January 21, pp. 14–15.

Morgan, Stuart. "A Can of Worms." *Frieze*, no. 27 (March–April), pp. 48–51.

Packer, William. "A Study in Naked Nostalgia." *London Financial Times*, February 4, p. xiv.

Schjeldahl, Peter. "Screenery." *Village Voice*, February 7–13, p. 77.

Zahm, Olivier. "John John." *Omnibus*, no. 15 (January), p. 13.

1995

Burkman, Greg. "John Currin at the Donald Young Gallery — Titties and Kitsch." *Stranger* 4, no. 25 (March 22–28), p. 16.

Guequierre, Nathan. "Slavishly Hip, Strangely Satisfying: Painting in the 90s Stresses Content over Form." *Shepherd Express* (Milwaukee), October 12.

Hackett, Regina. "Currin Celebrates Bad Taste." *Seattle Post-Intelligencer*, March 15, p. C4.

Jouannais, Jean-Yves. "John Currin at Frac Limousin." *Artpress*, no. 206 (October), pp. 70–71.

Lambrecht, Luk. "John Currin." *De Morgen* (Brussels), September 14.

Mahoney, Robert. "John Currin at Andrea Rosen Gallery." *Time Out New York* (November 1–8), p. 24.

Searle, Adrian. "Try to Figure It Out." *Independent* (London), December 12, sec. 2, pp. 8–9.

Seward, Keith. *John Currin Oeuvres/Works 1989–1995*. Exh. cat. Limoges, France: Fonds Régional d'Art Contemporain Limousin

———. "The Weirdest of the Weird." *Flash Art* 28, no. 185 (November–December), pp. 78–80.

Smith, Roberta. "Art in Review: Currin's Ambiguities: John Currin at Andrea Rosen Gallery." *New York Times*, November 17, p. C30.

1994

Decter, Joshua. "John Currin at Andrea Rosen Gallery." *Artforum* 32, no. 9 (May), pp. 100–1.

Dustin, Jo. "Critical Distance, Ado Gallery, Antwerpen." *L'Annuel de l'Art*, pp. 83–84.

Humphrey, David. "New York Fax: John Currin at Andrea Rosen Gallery," *Art Issues*, no. 33 (May/June), pp. 32–33.

Lebrero Stals, Jose. "John Currin at Ado." *Flash Art* 27, no. 174 (January–February), p. 106.

Papadopoulos, Helena. "John Currin." *Arti* (Athens) 22 (November–December), pp. 112–39.

Saltz, Jerry. "A Year in the Life: Tropic of Painting." *Art in America* 82, no. 10 (October), pp. 90–101.

1993

Aupetitallot, Yves. "Project Unite." *Purple Prose,* no. 3 (summer), p. 90.

Bracke, Eric. "Grote vis in kleine vijer: New Yorkse schilder John Currin in ADO Gallery." *De Morgen* (Brussels), August 17, p. 12.

Currin, John. "Cherchez la femme PEINTRE! — A Parkett Inquiry." *Parkett,* no. 37, pp. 146–47.

Doove, Edith. "John Currin at Ado Gallery, Antwerp." *Metropolis M,* no. 5 (October), p. 49.

Johnson, Ken. "John Currin at Andrea Rosen," *Art in America* 81, no. 1 (January), p. 104.

Lambrecht, Luk. "Kijk eens door het raam." *De Morgen* (Brussels), September 17.

Minetti, Maria Giulia. "In primo piano la biennale di venezia e l'arte riparte dai punto cardinal." *L'Uomo Vogue* (Rome), no. 241 (June), pp. 100–3.

Stals, Jose Lebrero. "Frankfurt — Prospect '93." *Flash Art* 26, no. 170 (May–June), pp. 97 and 128.

Troncey, Eric. "Naakt en kneedbaar," *Metropolis M,* no. 3 (June), cover and pp. 33–37.

Zahm, Olivier. "John Currin." *Purple Prose,* no. 4 (fall), p. 13.

1992

Borgstrom, Peter. "Den vite mannens konst har fatt konkurrens." *Dagens Nyheter* (Stockholm), November 22, sec. B, Kultur et Nojen, pp. 2–3.

D'Amato, Brian. "Spotlight: John Currin." *Flash Art* 25, no. 165 (summer), p. 105.

Faust, Gretchen. "New York in Review: *Shared Skin: Sub-Social Identifiers.*" *Arts Magazine* 66, no. 5 (January), pp. 85–86.

Hess, Elizabeth. "Difficult Pleasures." *Village Voice,* April 21, p. 93.

Metzger, Rainer. "Malerei: Painting as a Matter of Subject." *Flash Art* 25, no. 162 (January–February), p. 122.

1991

Mahoney, Robert. "New York in Review: *John Currin.*" *Arts Magazine* 65, no. 8 (April), p. 104.

1990

Decter, Joshua. "New York in Review: *John Currin.*" *Arts Magazine* 64, no. 8 (April), pp. 105–6.

Friis-Hansen, Dana. *(not so) Simple Pleasures.* Exh. cat. Cambridge, Mass.: MIT List Visual Arts Center.

Zinsser, John. "Losses in Translation, Three Young Painters Give an Unfamiliar Edge to Portraiture." *Arts Magazine* 65, no. 2 (October), pp. 88–90.

1989

Anderson, Alexandra. "The Next Generation." *Smart* (September/October), pp. 69–79.

Acknowledgments

Many individuals at our institutions and beyond deserve our gratitude for their work on this project. Special thanks are due to the lenders to this exhibition — we appreciate their willingness to part with their paintings for an extended period of time. It has been remarkable to discover how passionately engaged collectors of John Currin's paintings are with his work. We are also grateful to John Currin's representatives, Andrea Rosen at Andrea Rosen Gallery in New York, Sadie Coles at Sadie Coles HQ in London, and Shaun Caley Regen at Regen Projects in Los Angeles, and their respective staffs, especially Laura Mackall at Andrea Rosen Gallery, who have assisted us in all aspects of our endeavors. For organizing the presentation of this exhibition at the Whitney Museum, we thank curator Larry Rinder.

Our colleagues at both institutions have been enormously dedicated to this exhibition. At the MCA, we would like to acknowledge the support of Robert Fitzpatrick, Pritzker Director; Elizabeth Smith, James W. Alsdorf Chief Curator; and Francesco Bonami, Manilow Senior Curator. Lela Hersh, Director of Collections and Exhibitions, displayed her consummate skill with contracts, budgets, and organizational details, and Jennifer Draffen, Registrar, expertly supervised the registration aspects of the entire project. Patrick McCusker, Director of Development, ably led the exhibition's fundraising initiatives. We are also grateful to Renée Jessup, Coordinator of Media Relations, for her help in publicizing this project in the United States. Dominic Molon, Associate Curator, and Alison Pearlman, former Assistant Curator provided valuable insights.

At the Serpentine, we would like to acknowledge the support of Julia Peyton-Jones, Director. We would also like to thank Claire Fitzsimmons, Exhibition Organiser, whose commitment to this project has been invaluable. Mike Gaughan, Gallery Manager, and the installation team, have been crucial to all aspects of the presentation of John Currin's work in London. Louise McKinney and Natasha Roach, Development Managers, were tireless in securing financial support for this ambitious project. We would also like to thank Annabel Friedlein, Head of Press and Publicity, who attracted widespread media attention to the exhibition in London. Sally Tallant, Head of Education Programming, created an outstanding education and public event program.

This catalogue, which is copublished by the MCA and Serpentine Gallery in association with Harry N. Abrams, Inc., is the artist's first major monograph, extending beyond the scope of the exhibition to present an extensive account of Currin's work to date. We would like to express our gratitude to Robert Rosenblum for his insightful overview of Currin's work. At the MCA, Hal Kugeler, Director of Design and Publications, and Kari Dahlgren, Associate Director of Publications, have sensitively and enthusiastically guided this publication from conception to completion. Jennifer Harris, Coordinator of Rights and Reproductions, skillfully secured the rights for the illustrations. We are appreciative of Eric Himmel and Deborah Aaronson at Abrams for working with us to distribute this book widely. Without the involvement and commitment of Abrams, a definitive publication of this scale would not have been possible.

Our deepest thanks are reserved for John Currin, who was involved with all aspects of this project, from the selection of works for the exhibition to the design and production of this publication. It has been a privilege to have this opportunity to work so closely with him, and his challenging paintings have given us much to think about.

Staci Boris
Associate Curator
Museum of Contemporary Art, Chicago

Rochelle Steiner
Chief Curator
Serpentine Gallery, London

Photography Credits